Kara, as a professional artist with a Master's degree in Art as Therapy, is now drawing intricate designs for adult coloring books. Since adult coloring books have become a trendy activity for adults of all ages and professions, coloring her drawings will promote relaxation from a stressful lifestyle. And the added words of encouragement will be a source of strength and comfort.

Kara McDaniel

WORDS OF ENCOURAGEMENT
ILLUSTRATED WITH
FRUITS AND FLOWERS

AUSTIN MACAULEY PUBLISHERS™

LONDON * CAMBRIDGE * NEW YORK * SHARJAH

Copyright © Kara McDaniel (2019)

Ordering Information:
Quantity sales: special discounts are available on quantity purchases by corporations, associations, and others. For details, contact the publisher at the address below.

McDaniel, Kara
Words of Encouragement Illustrated with Fruits and Flowers

ISBN 9781641826051 (Paperback)
ISBN 9781641826068 (Hardback)
ISBN 9781641826075 (E-Book)

The main category of the book — ART / Techniques / Drawing

www.austinmacauley.com/us

First Published (2019)
Austin Macauley Publishers LLC
40 Wall Street, 28th Floor
New York, NY 10005
USA

mail-usa@austinmacauley.com
+1 (646) 5125767

CONTENTS

FRUITS

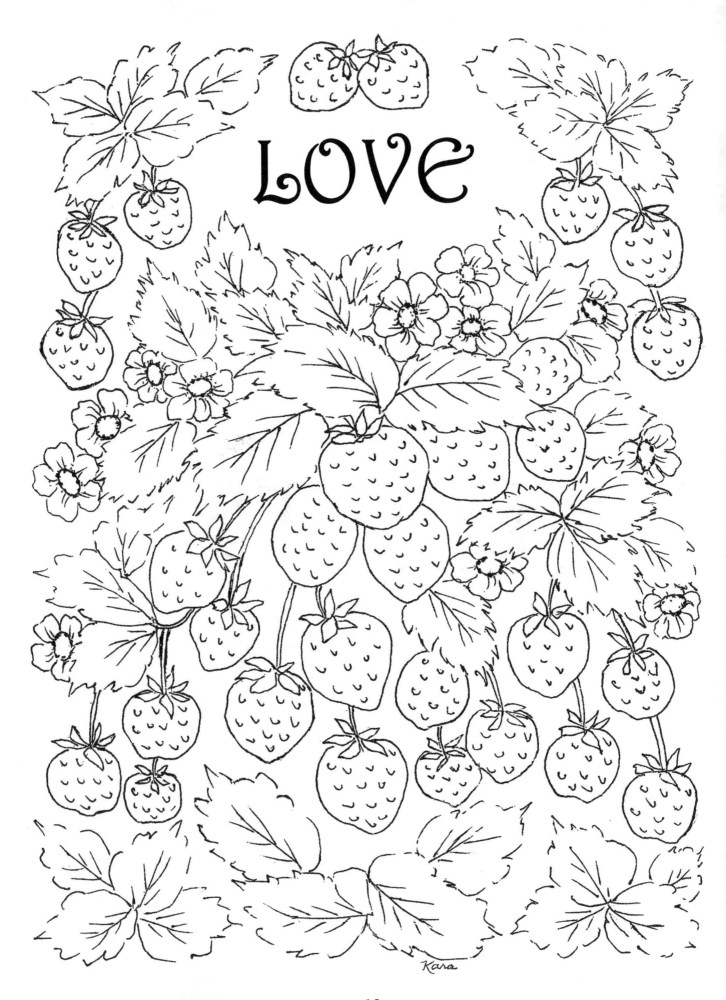

LOVE

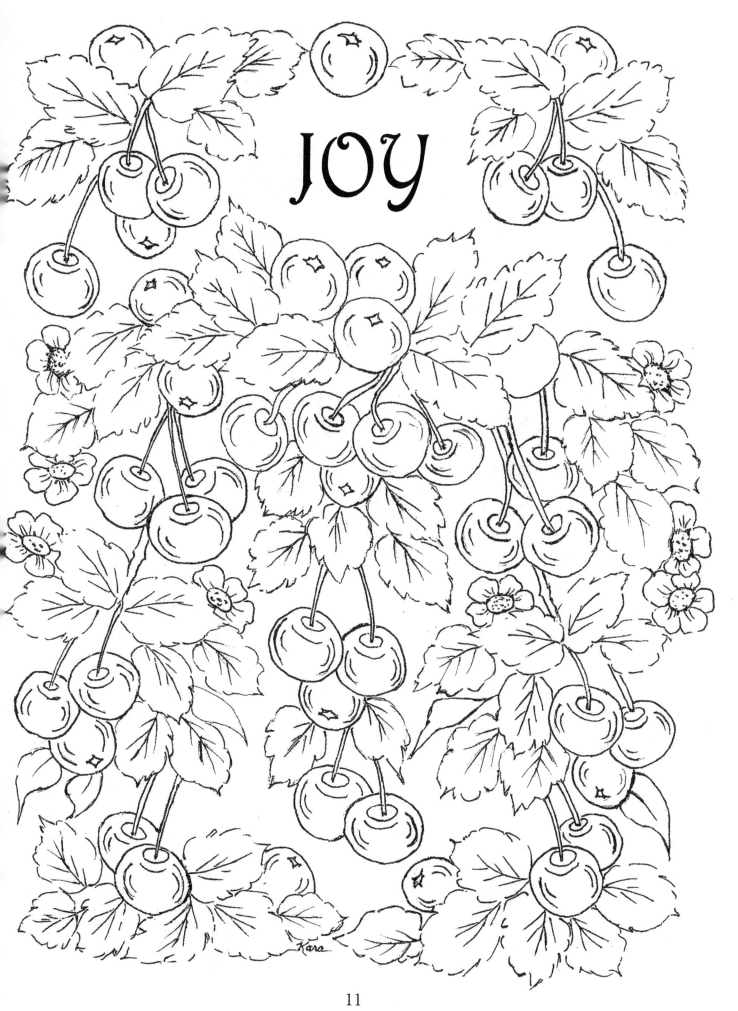

JOY

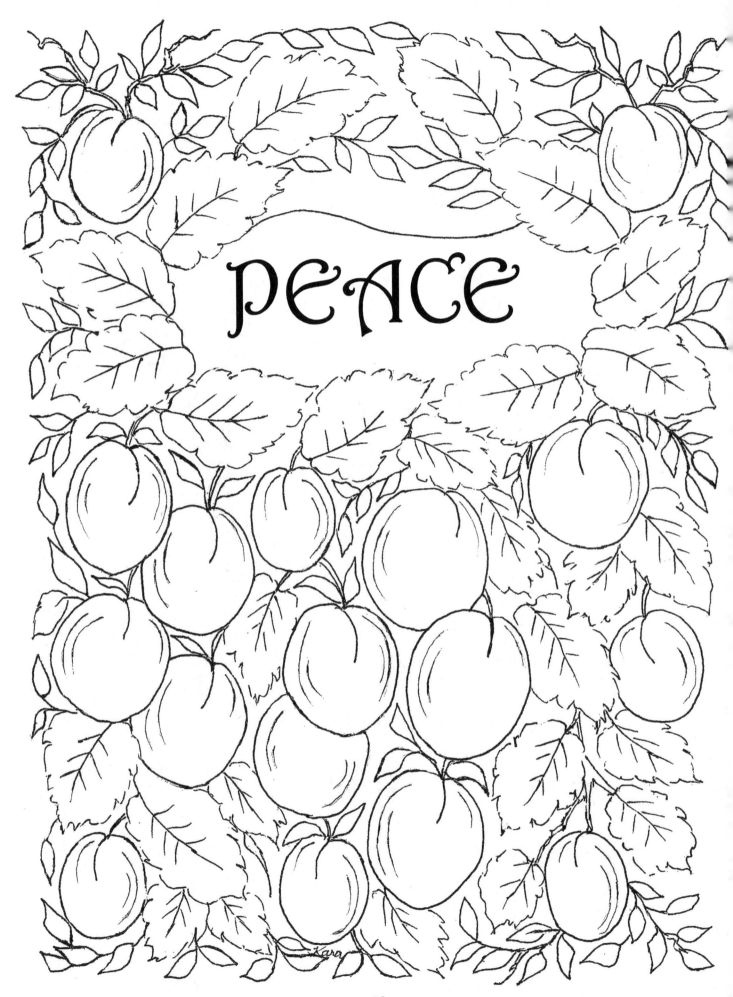

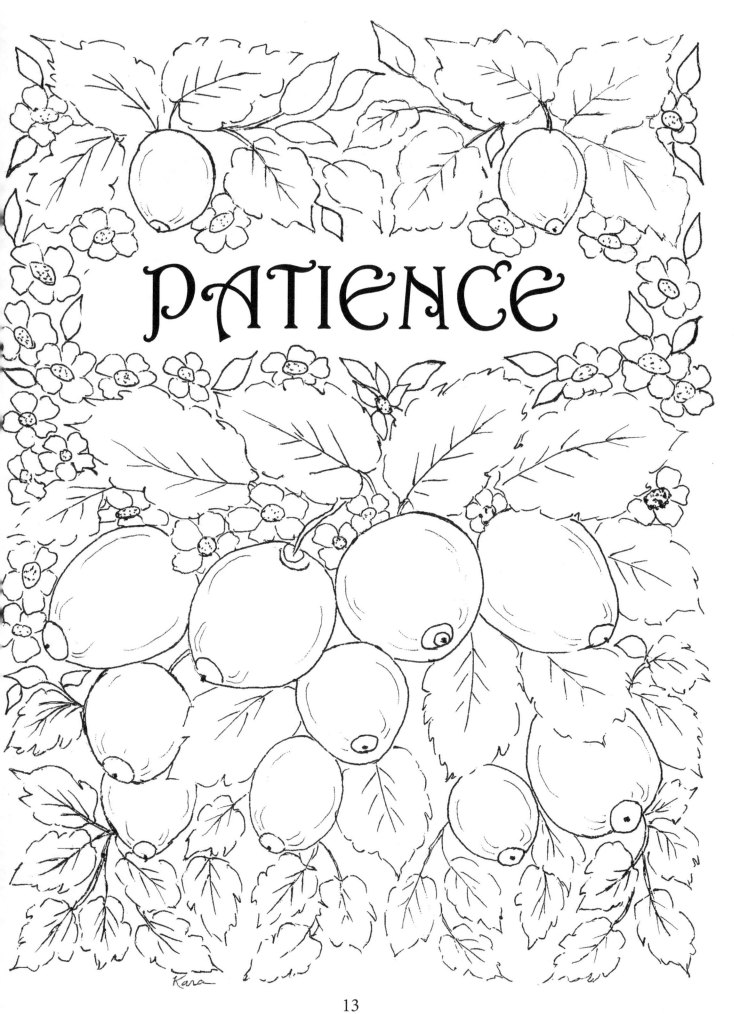

PATIENCE

KINDNESS

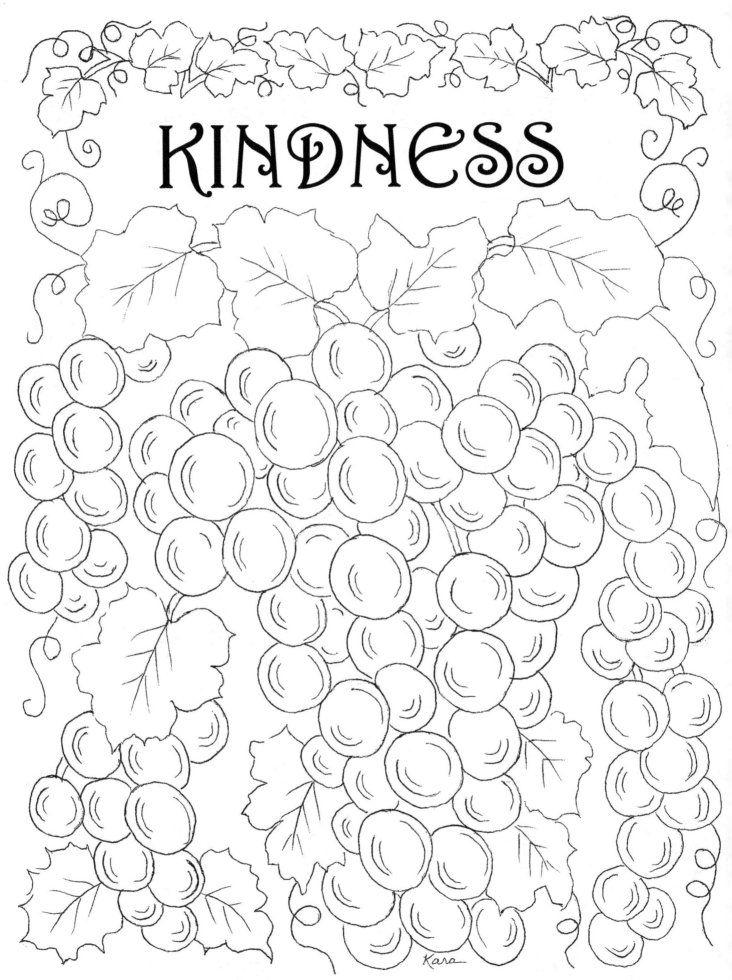

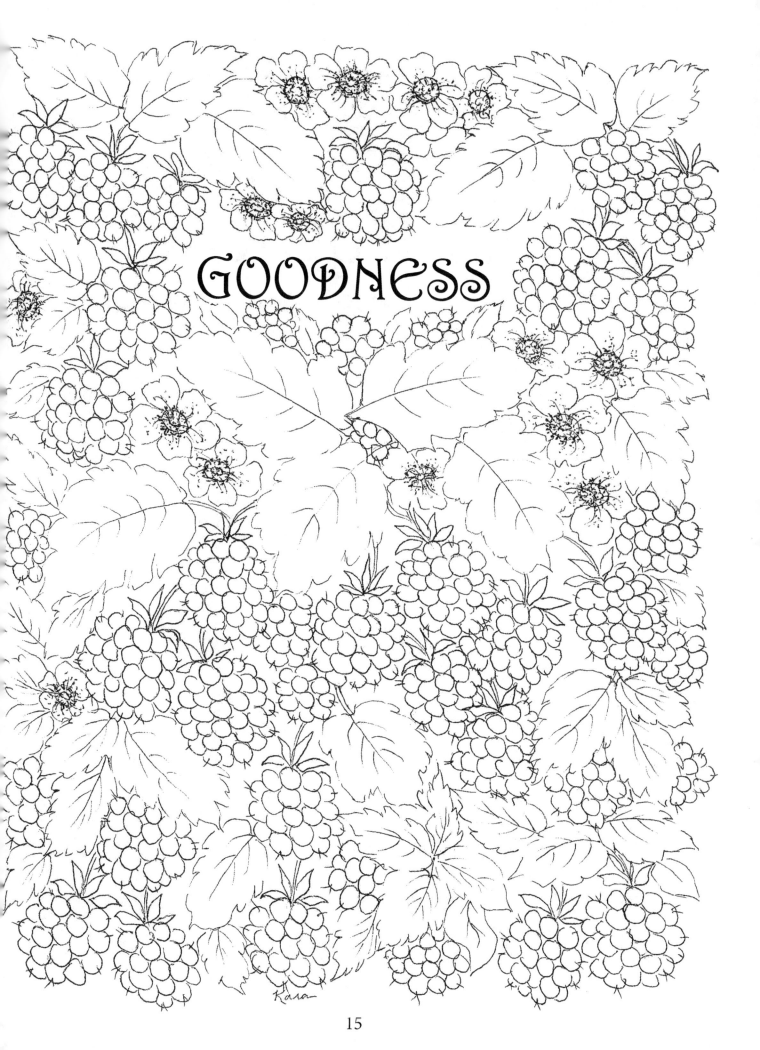

GOODNESS

15

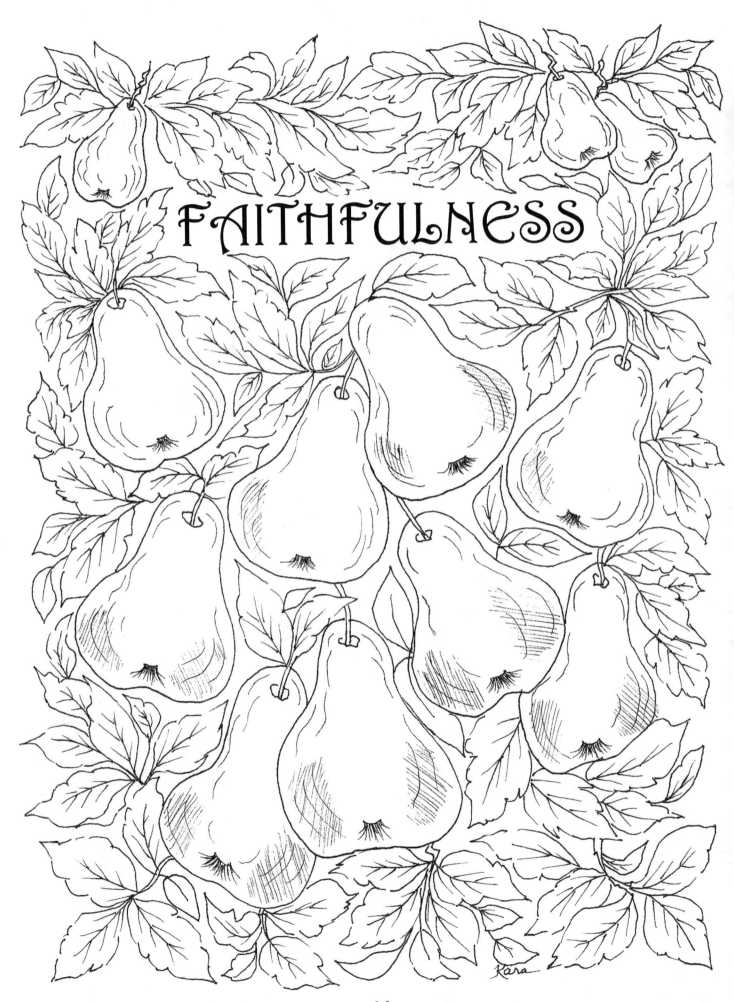

FAITHFULNESS

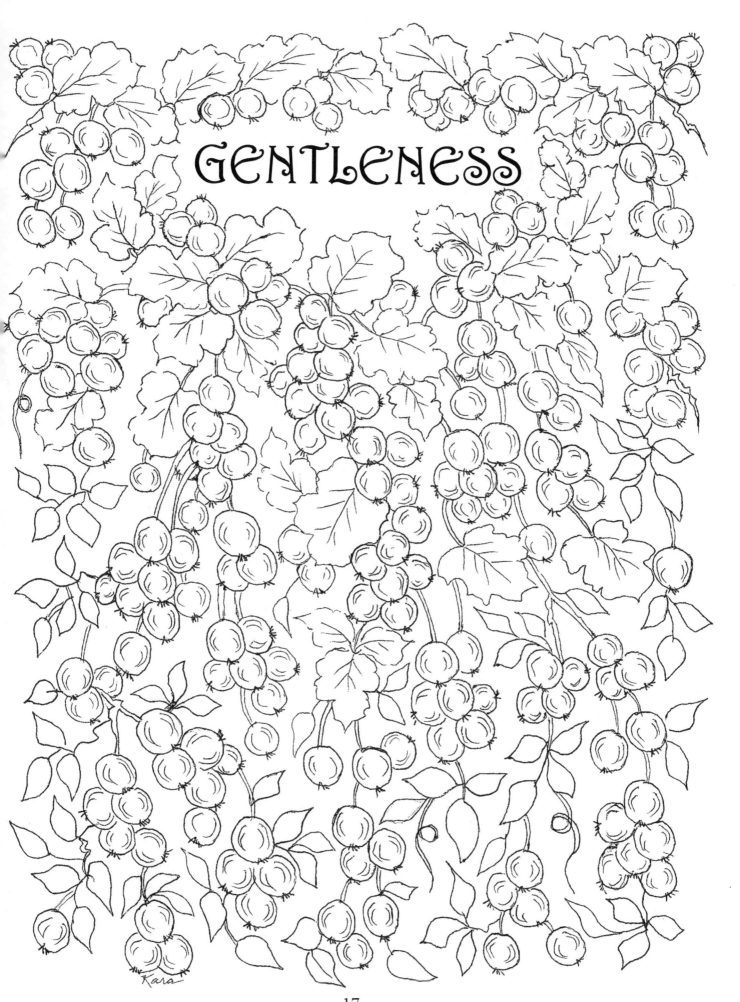

GENTLENESS

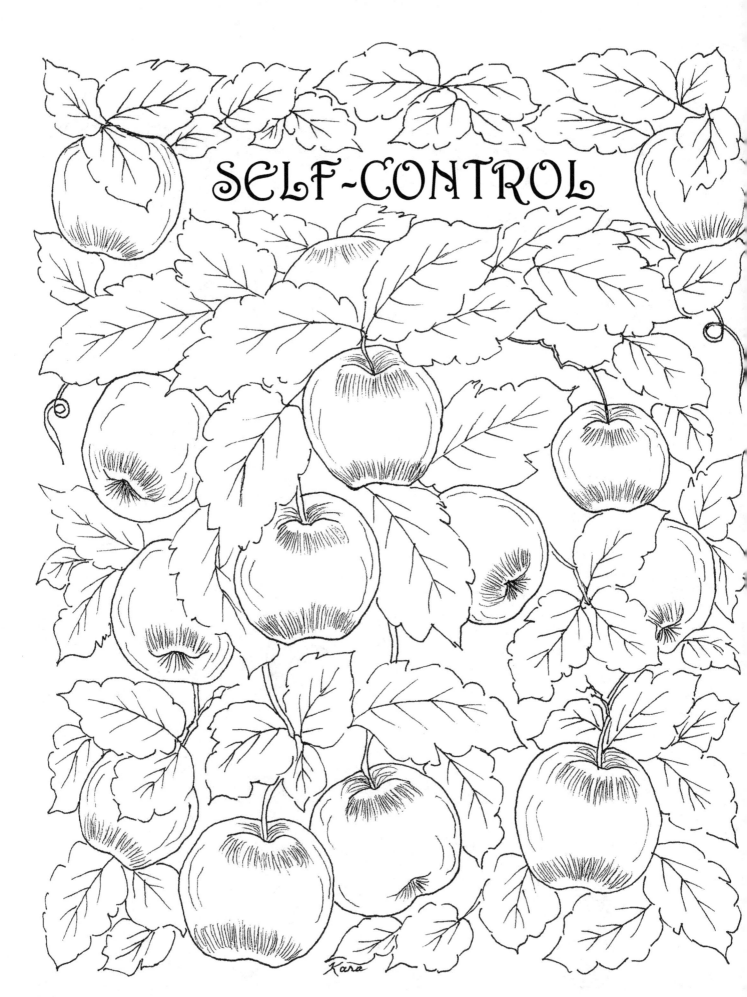

SELF-CONTROL

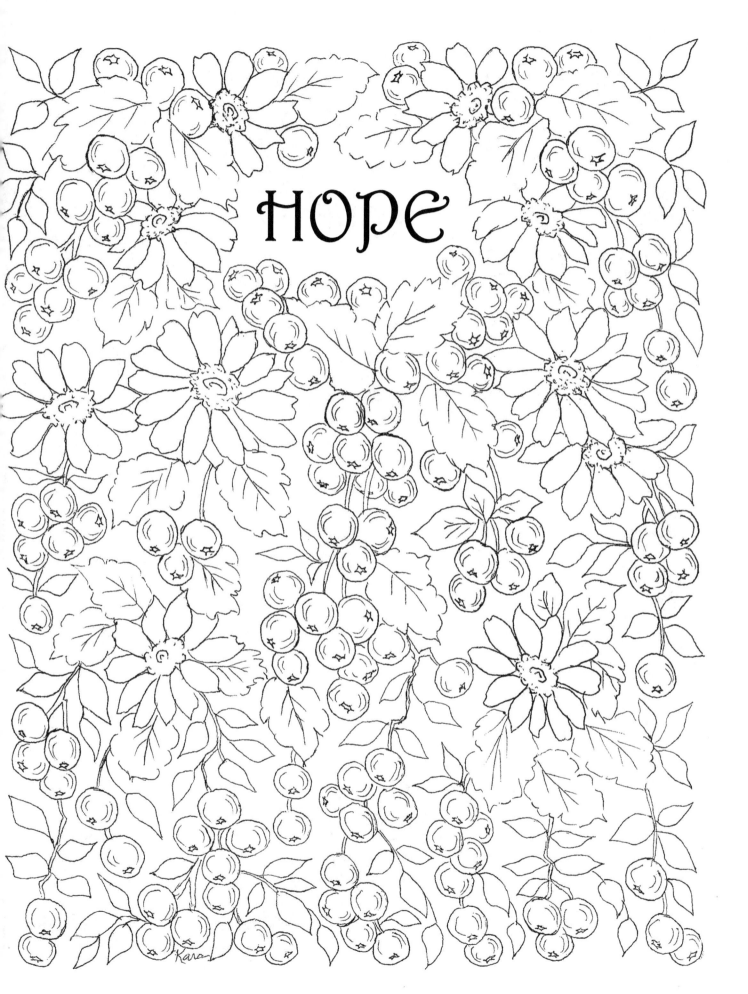

HOPE

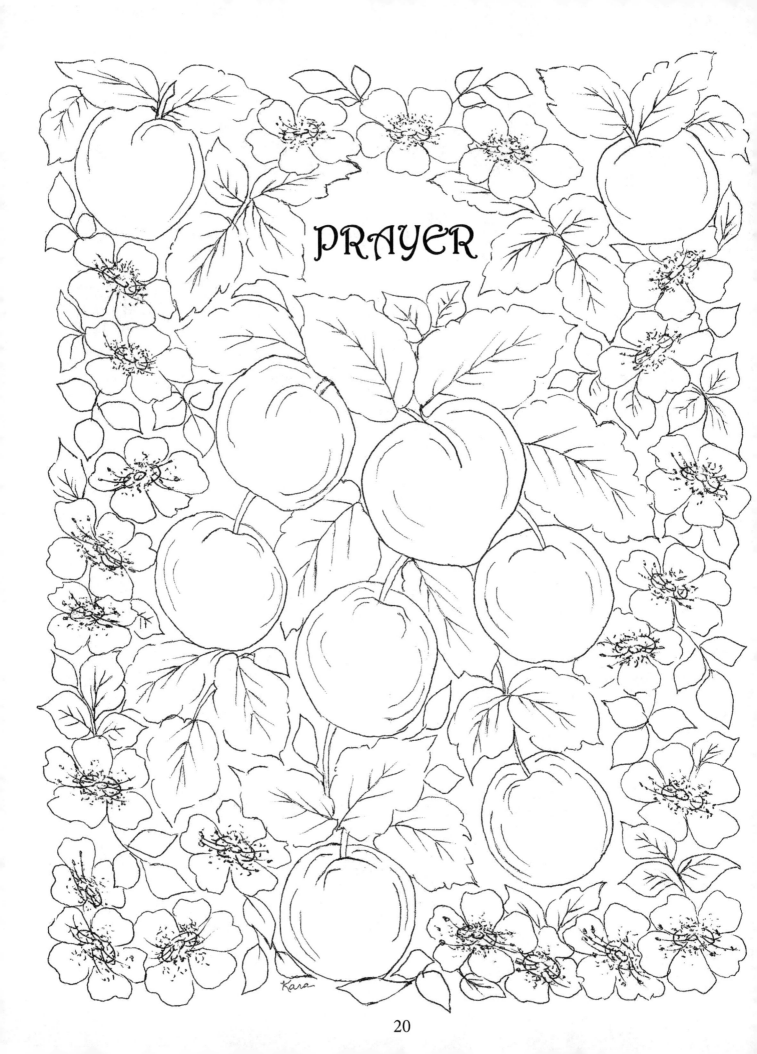

PRAYER

COMFORT

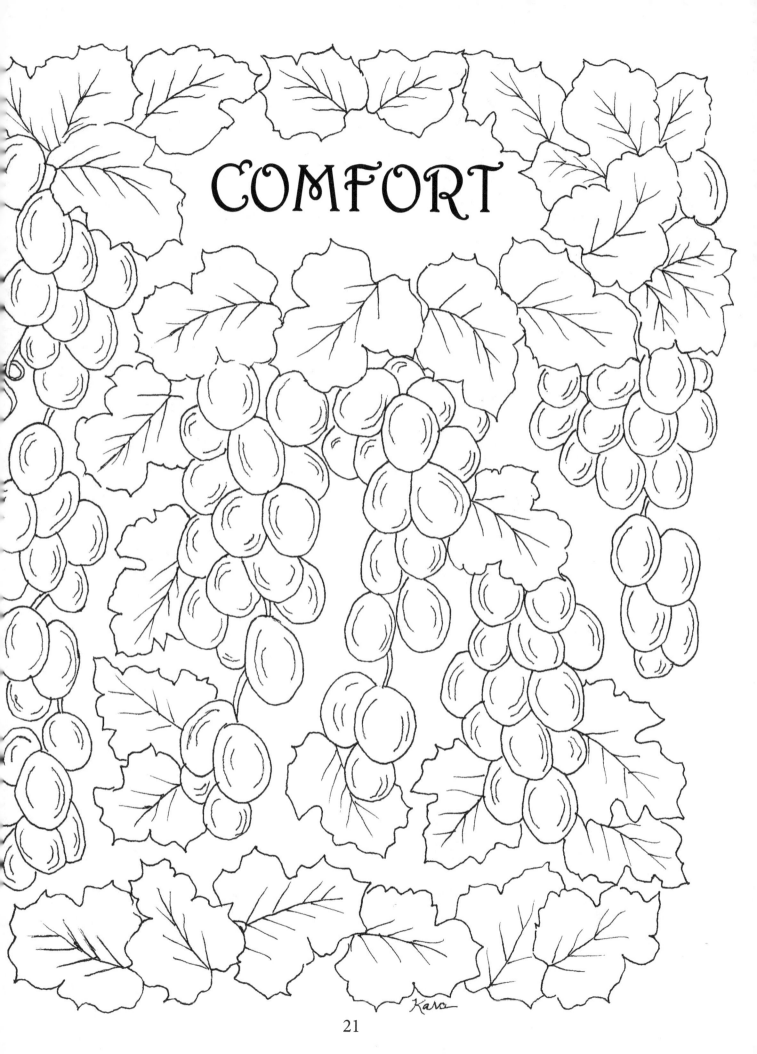

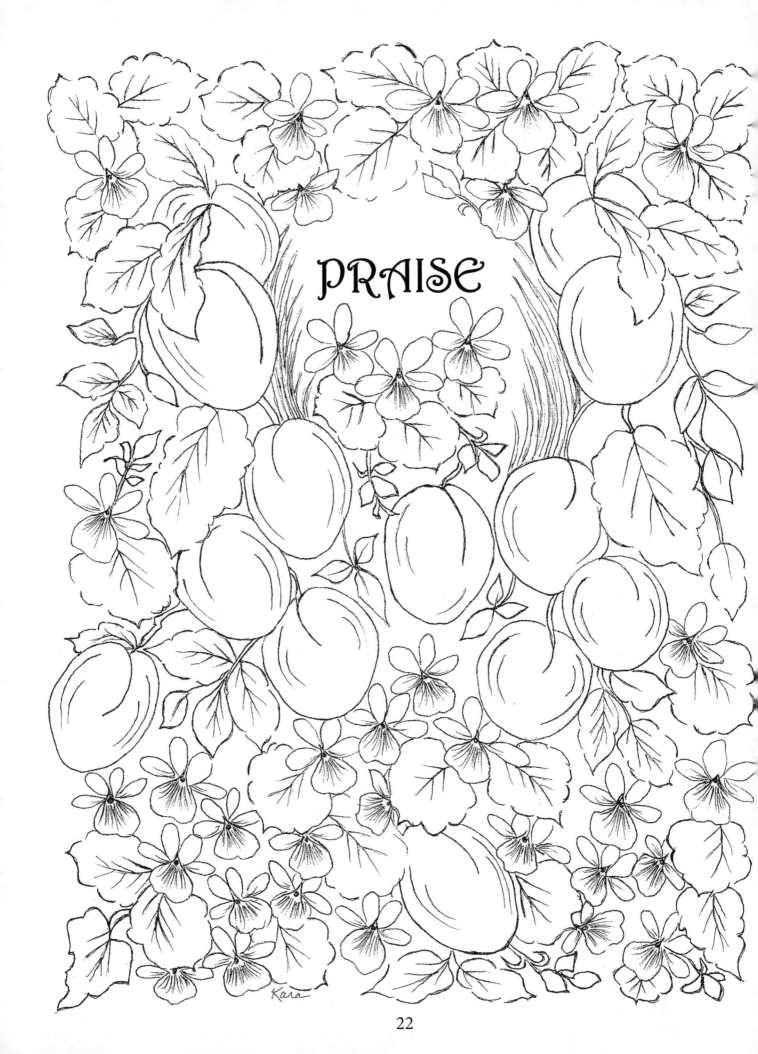

PRAISE

FREEDOM

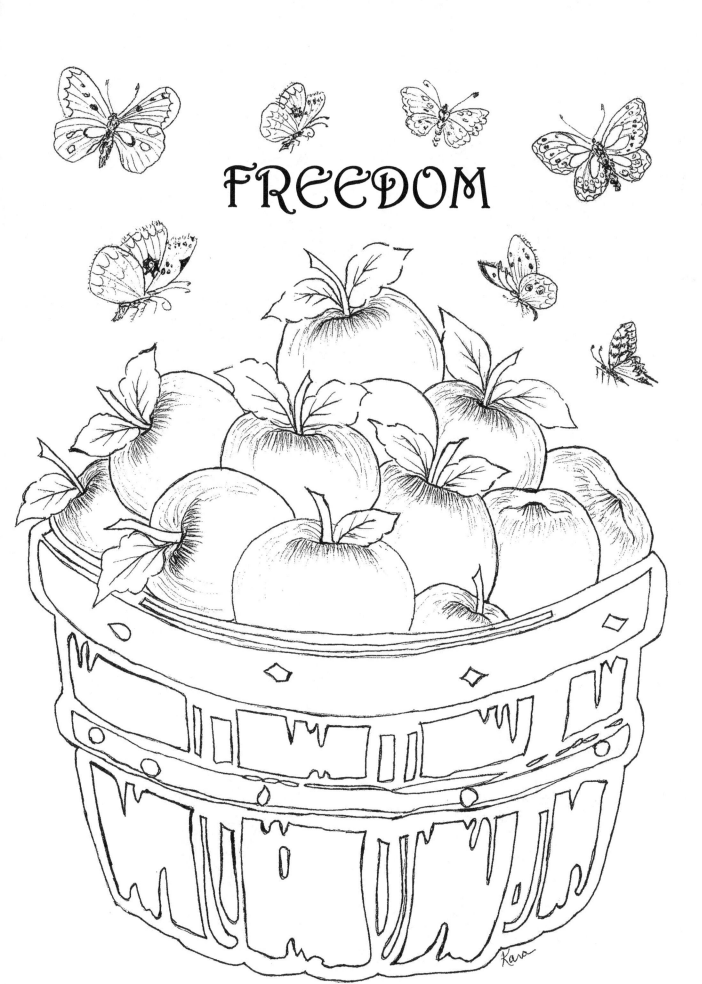

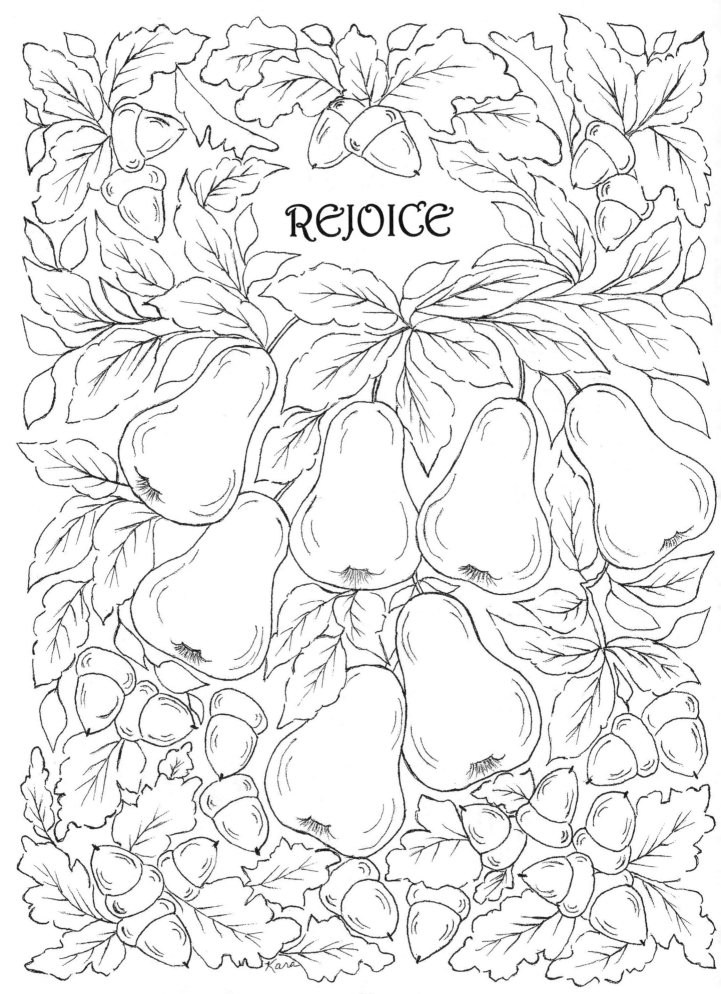

REJOICE

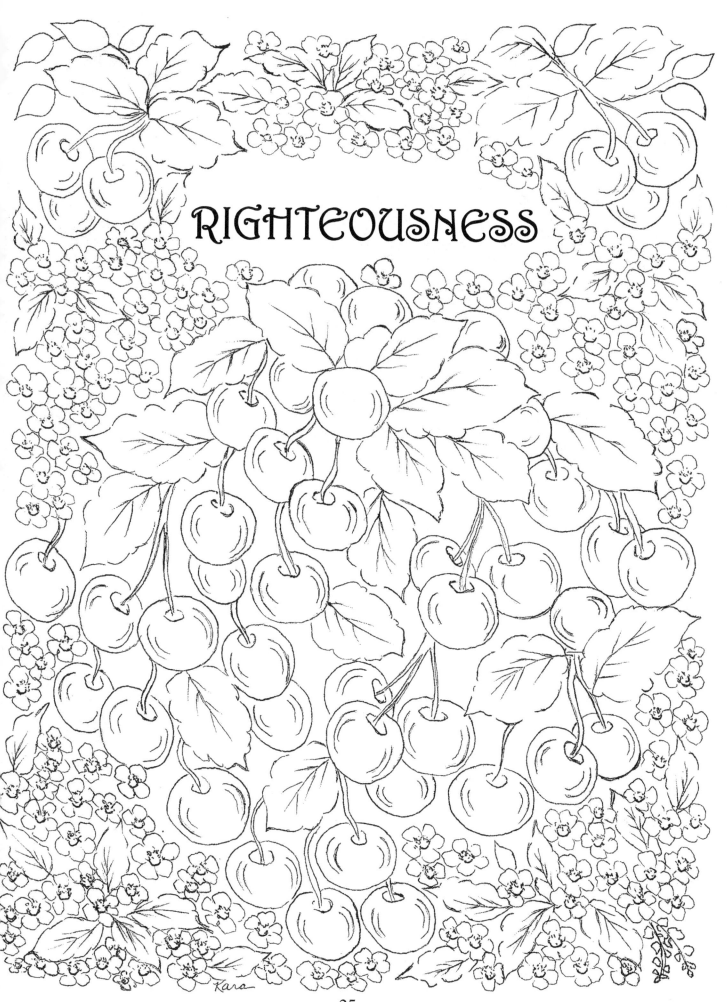

RIGHTEOUSNESS

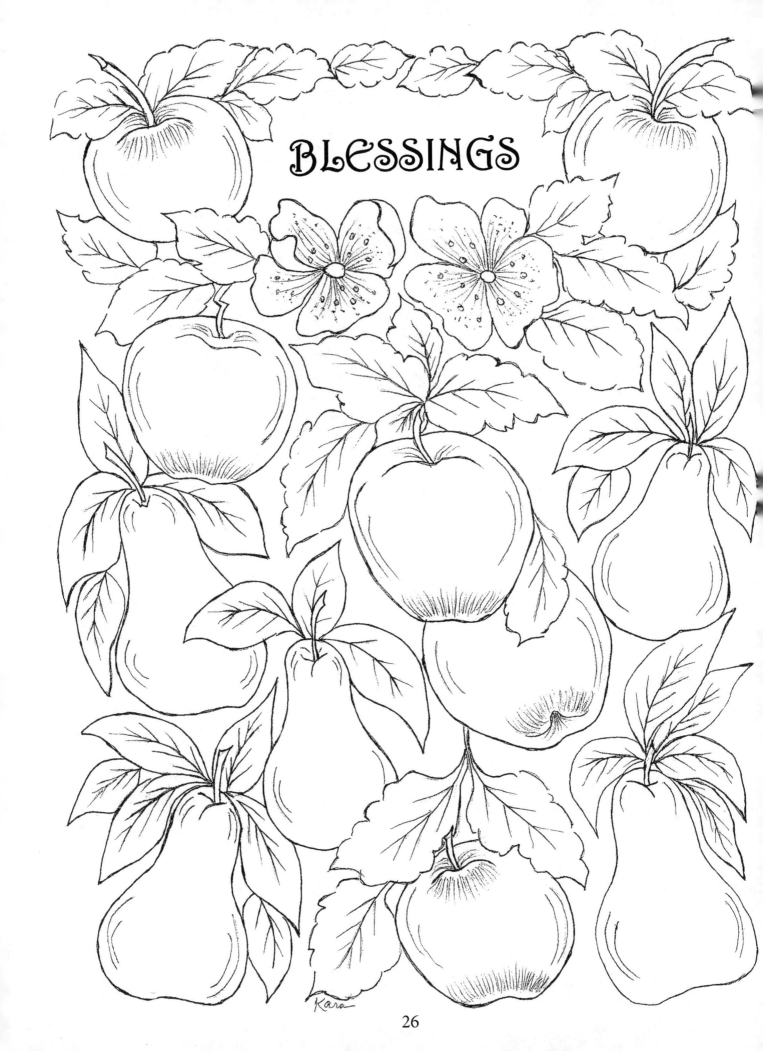

BLESSINGS

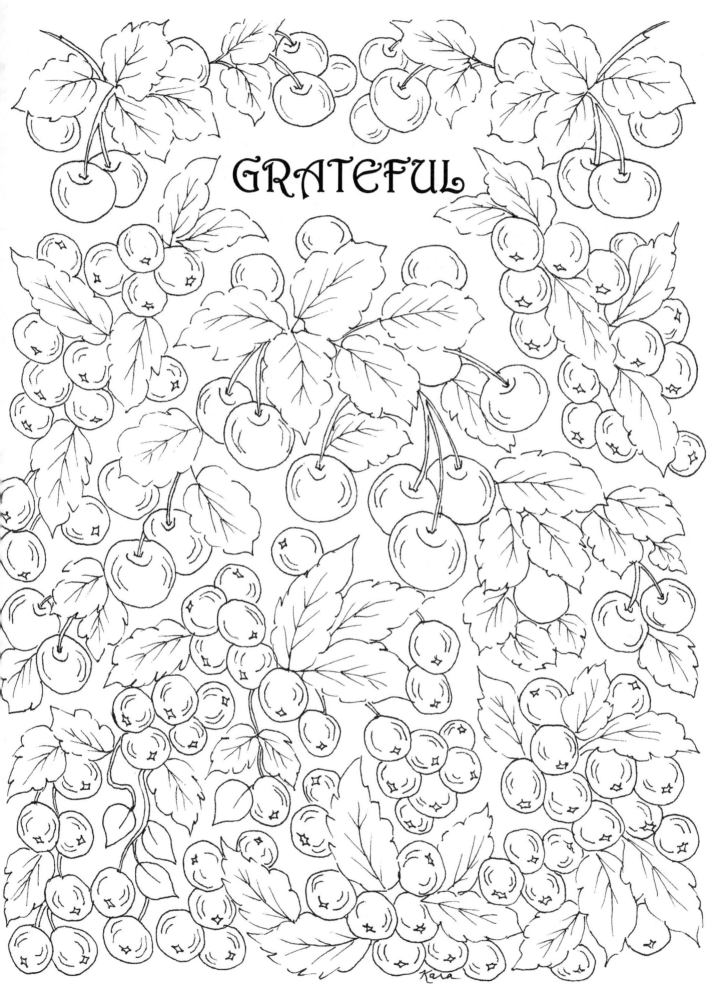

GRATEFUL

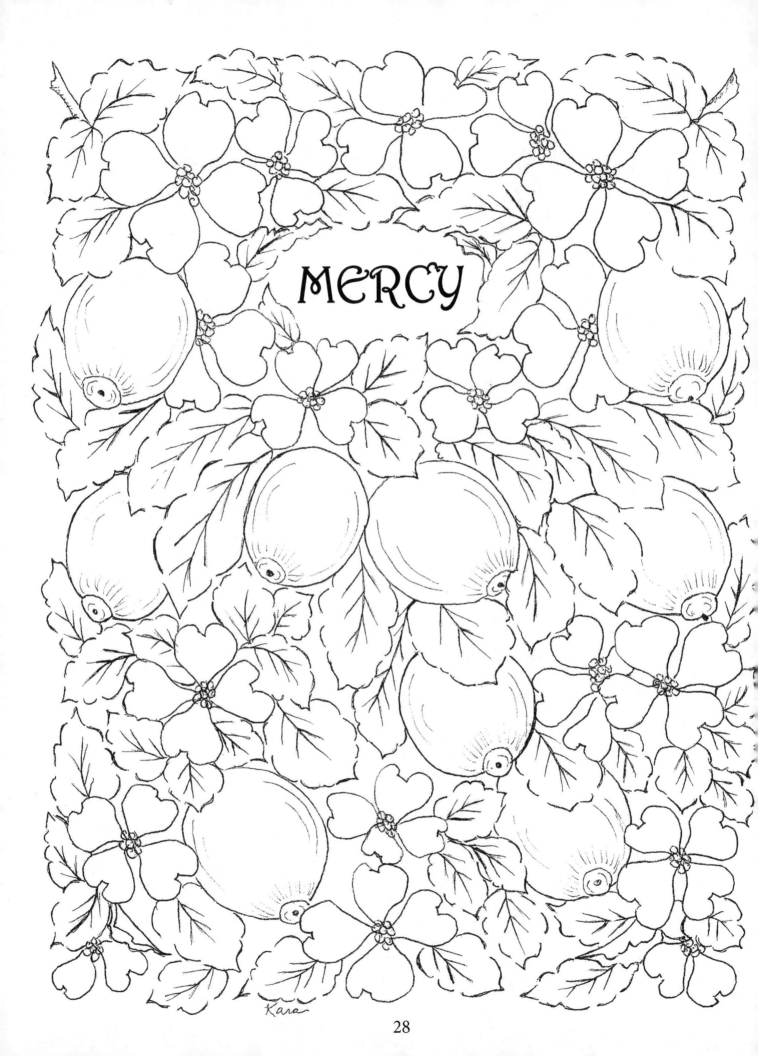

MERCY

Kara

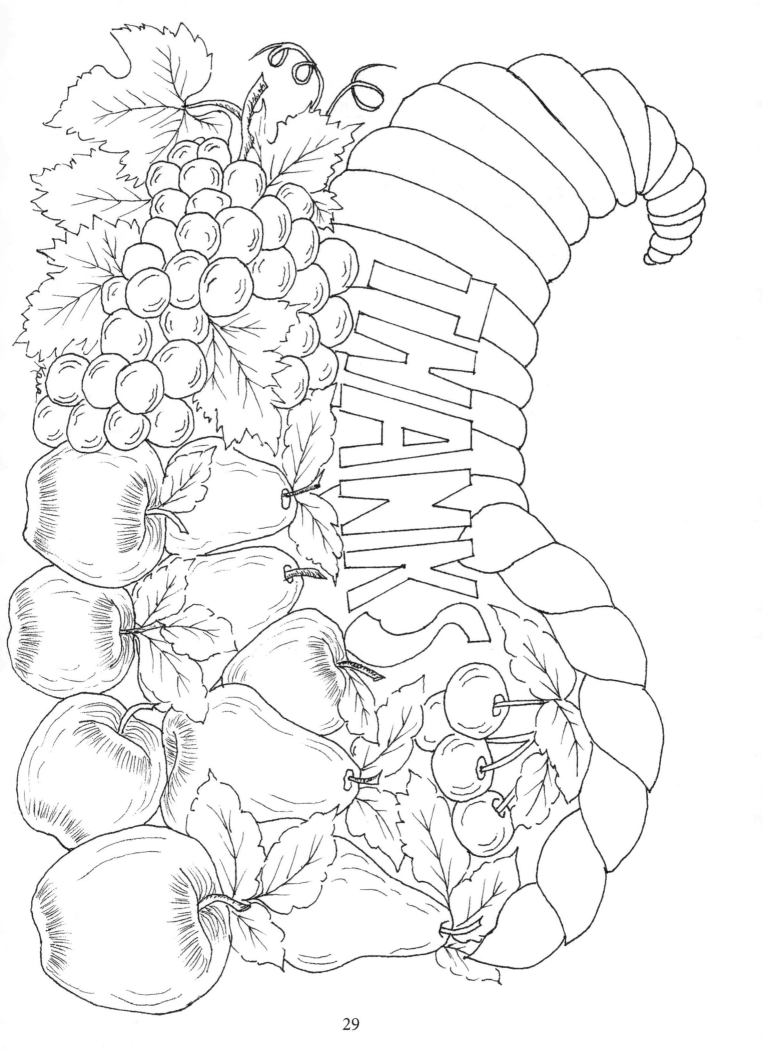

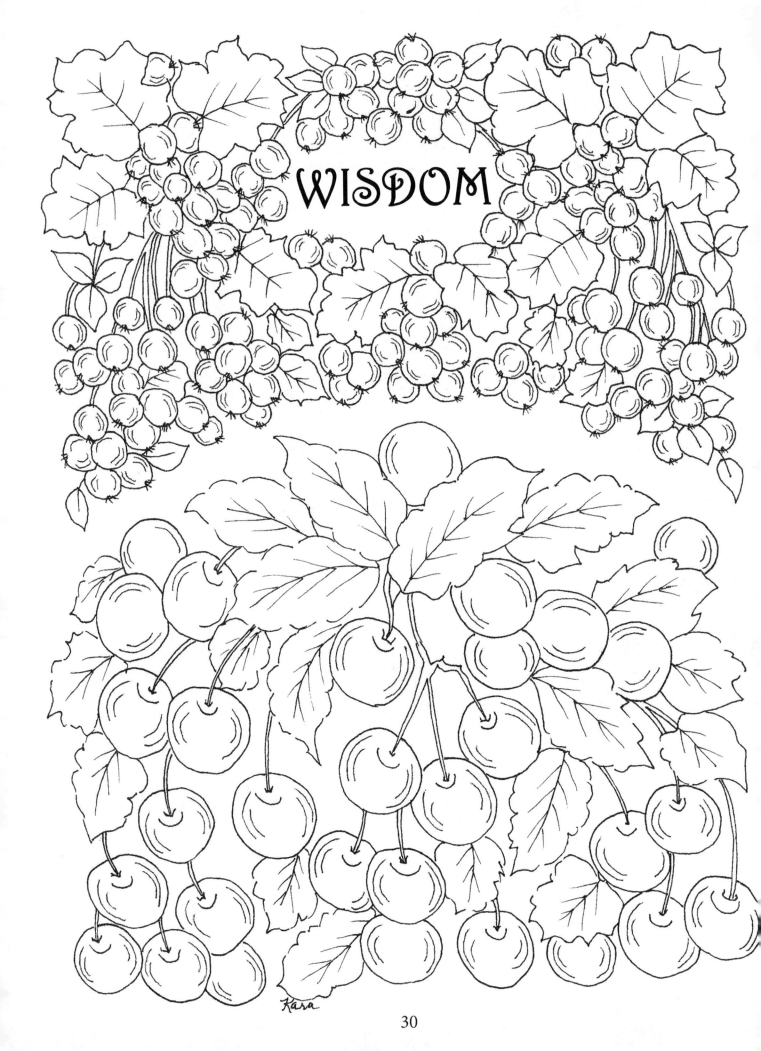

WISDOM

Kara

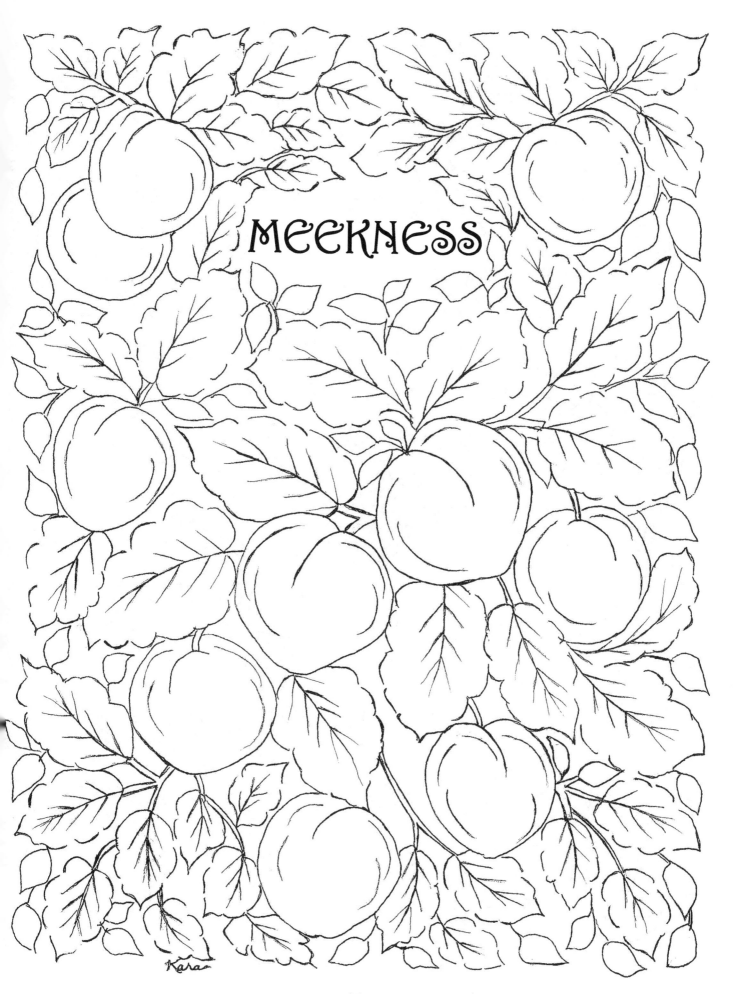

MEEKNESS

Kara

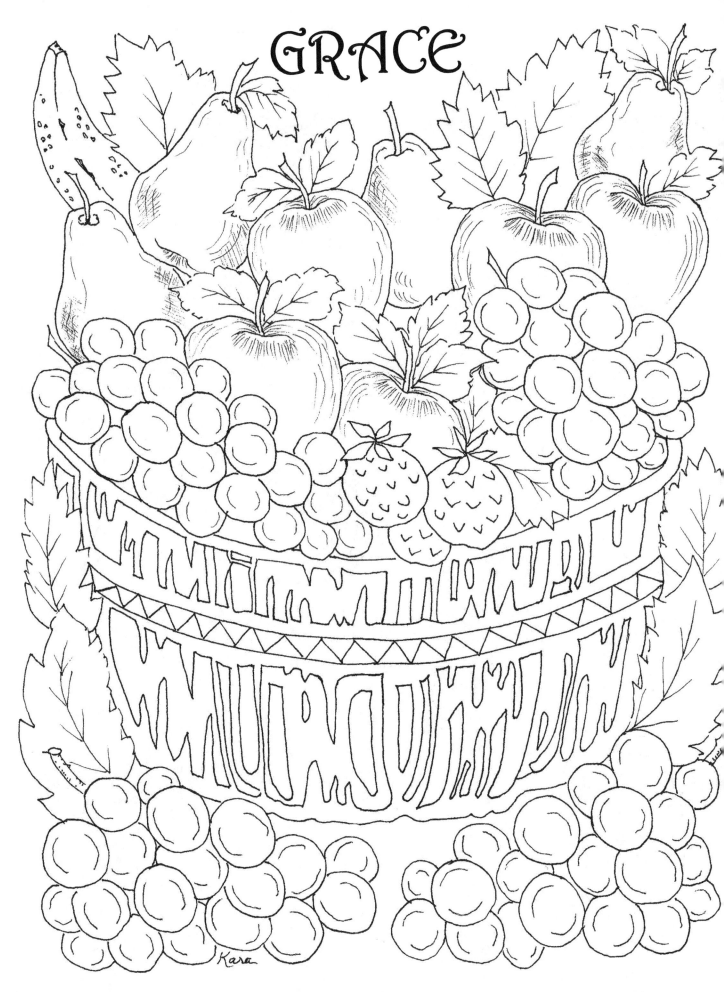

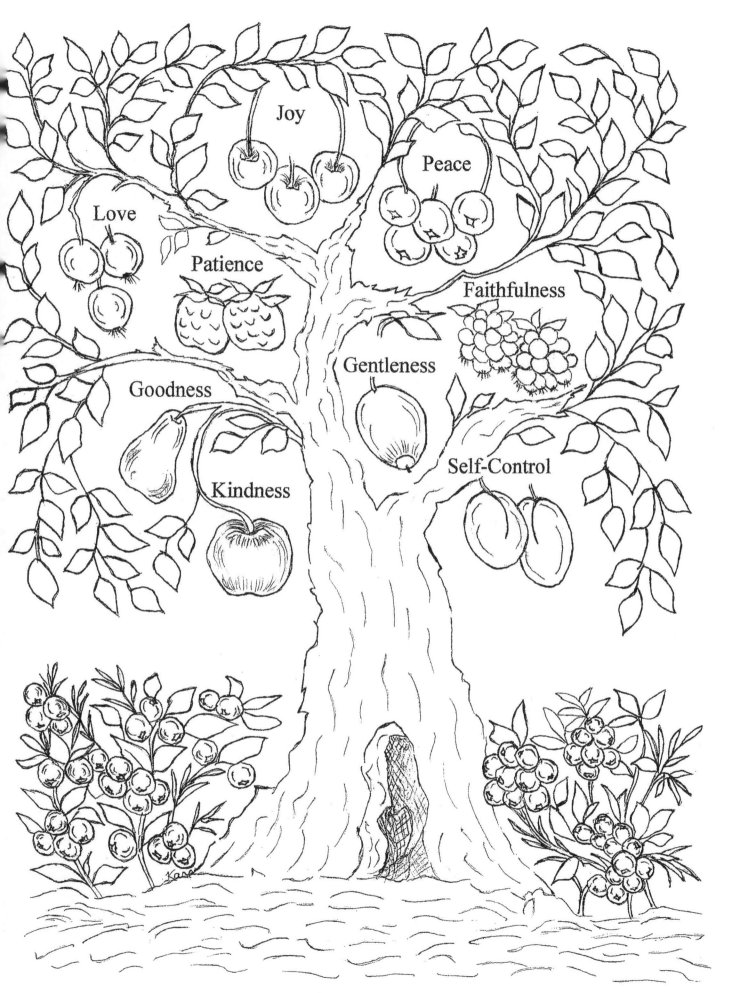

FLOWERS

Strength of the Lord

The faithfulness and strength of the Lord
shall be with you.

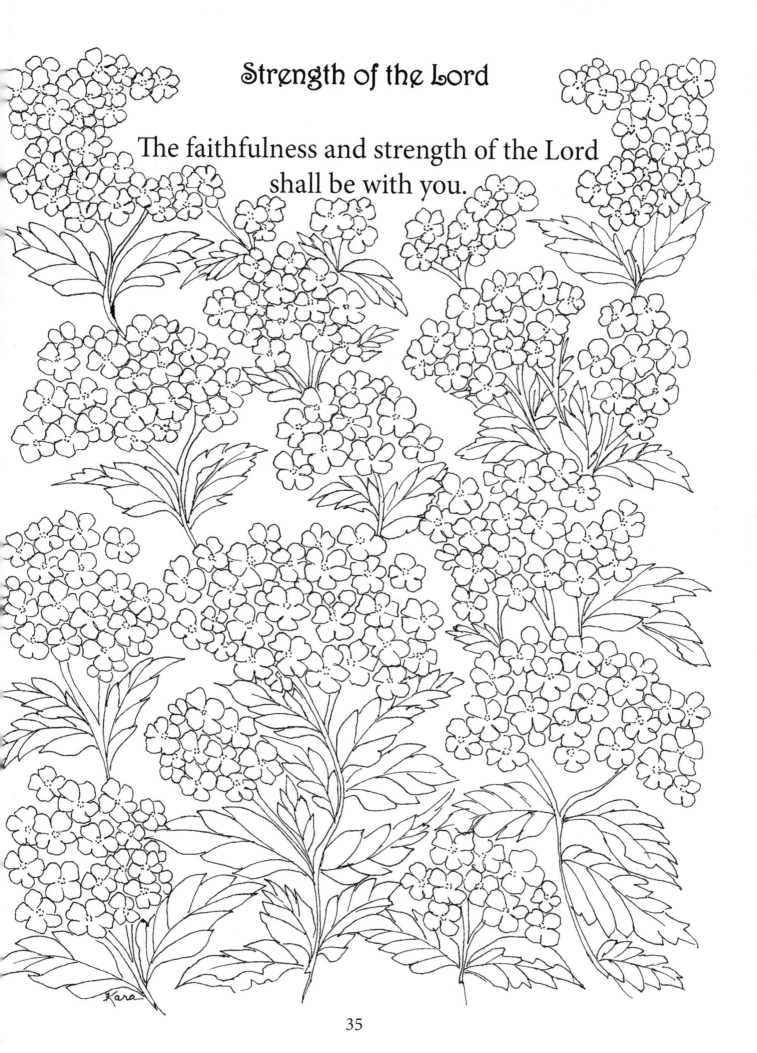

A Place of Blessing

You are in a place of blessing. And it is a place
of rejoicing, for it is a place where you will see
the good things of the Lord
taking place around you.

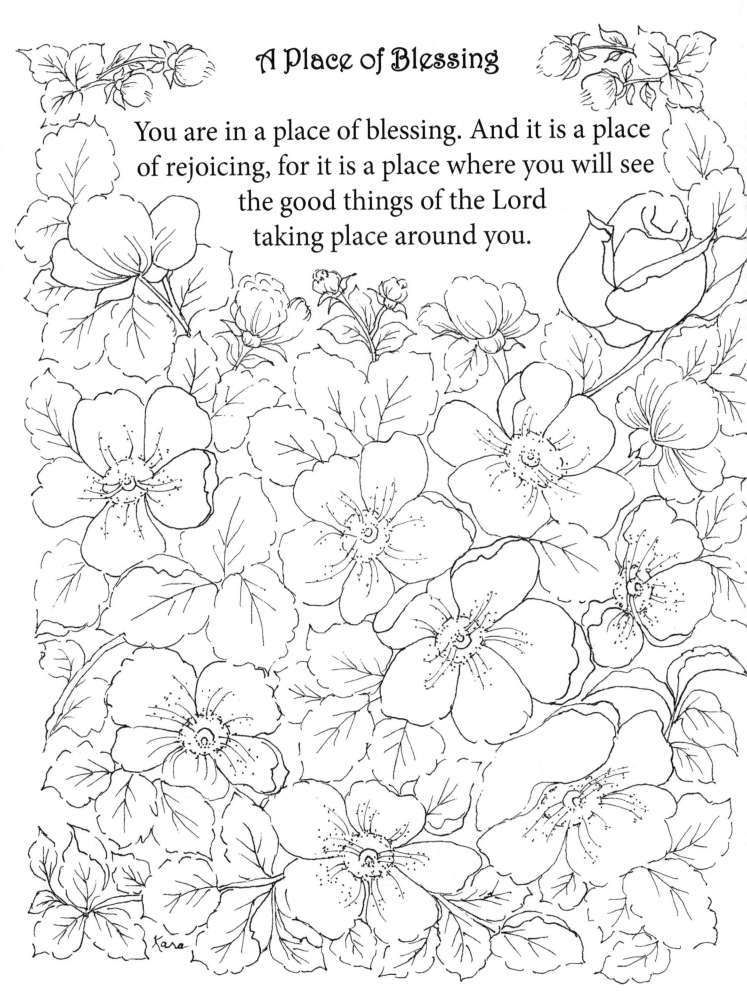

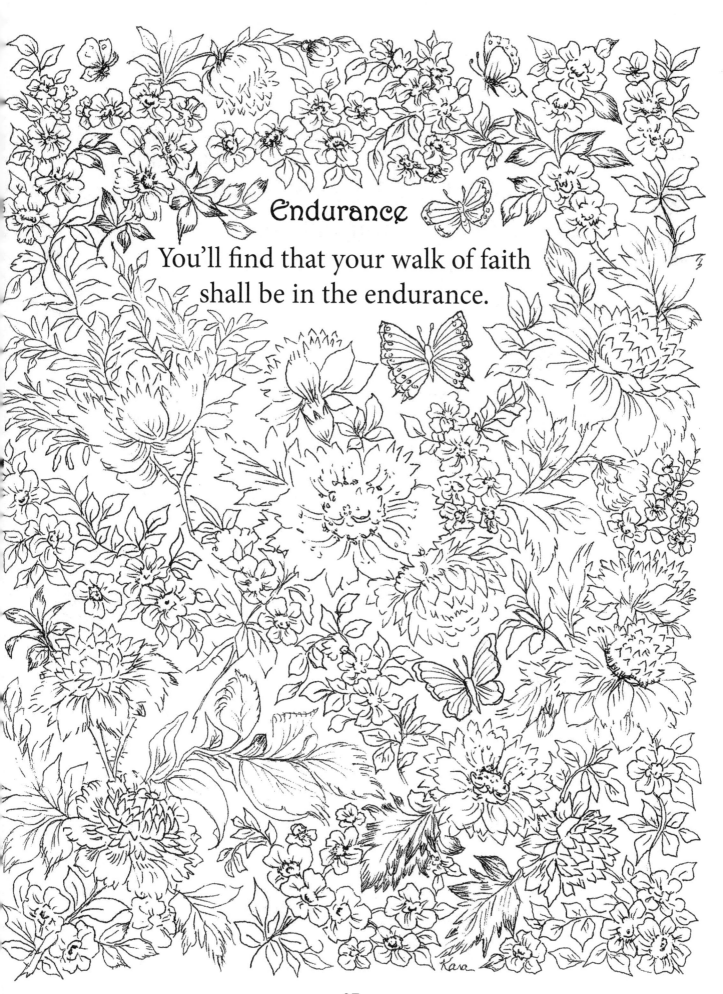

Endurance

You'll find that your walk of faith
shall be in the endurance.

Hope

Hope in itself will be a gift from the Lord,
because some will have walked without hope.
In the end, it will be a hope without
disappointment, for you will find that the Lord
is faithful, and that his words are true.

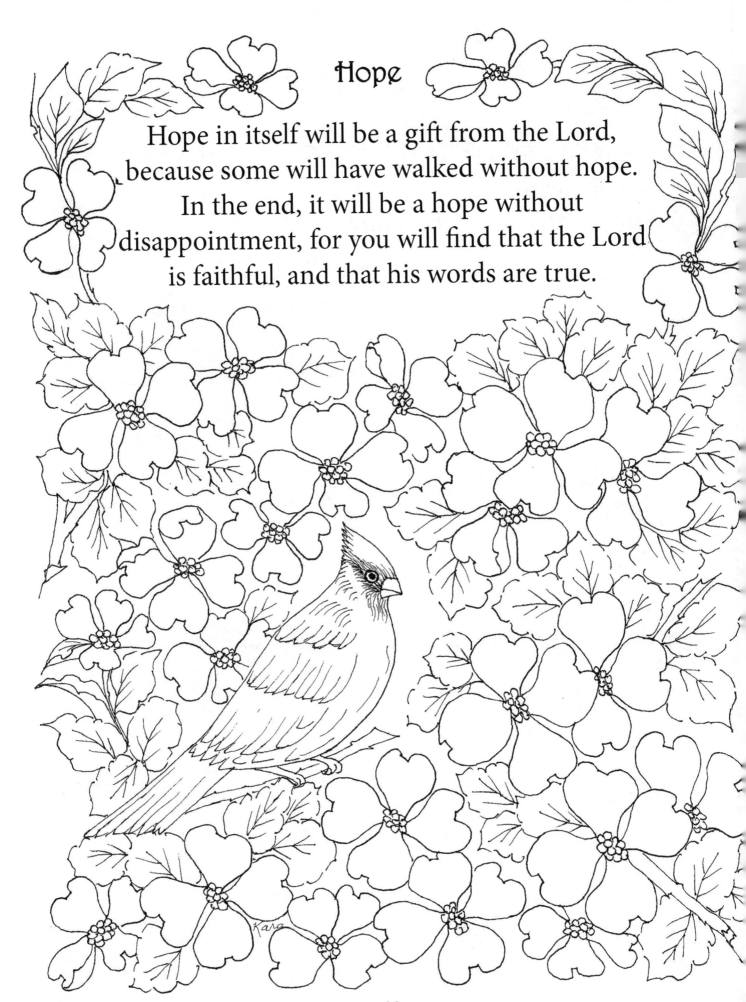

Walk in Love

As you walk in obedience and in love on the
pathway that the Lord has given you, you will
know the faithfulness and goodness of the Lord.

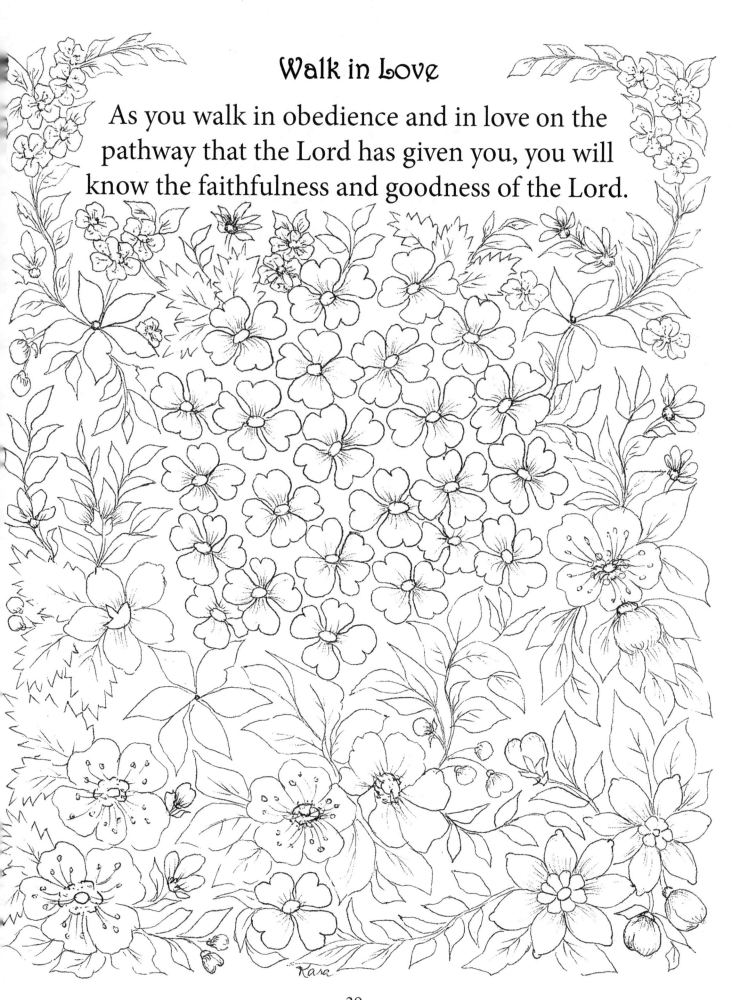

Walk Honestly

As you walk honestly in simplicity and love
before the Lord, others shall seek to know
the source of that love, and shall come
to know the Lord.

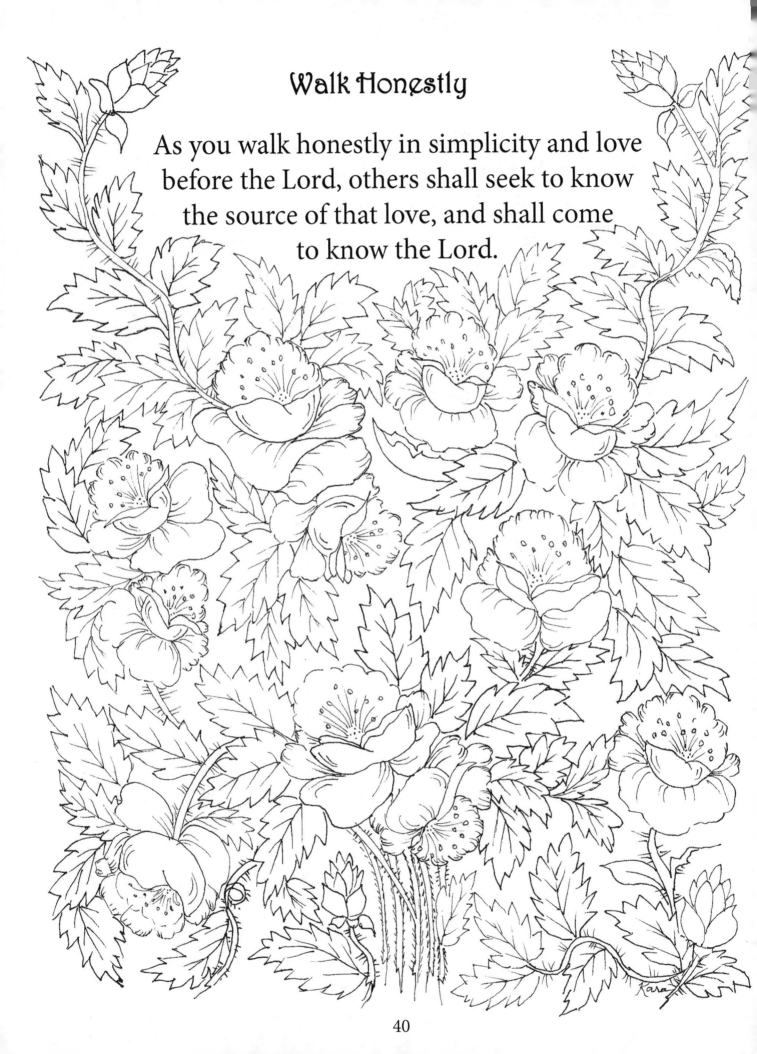

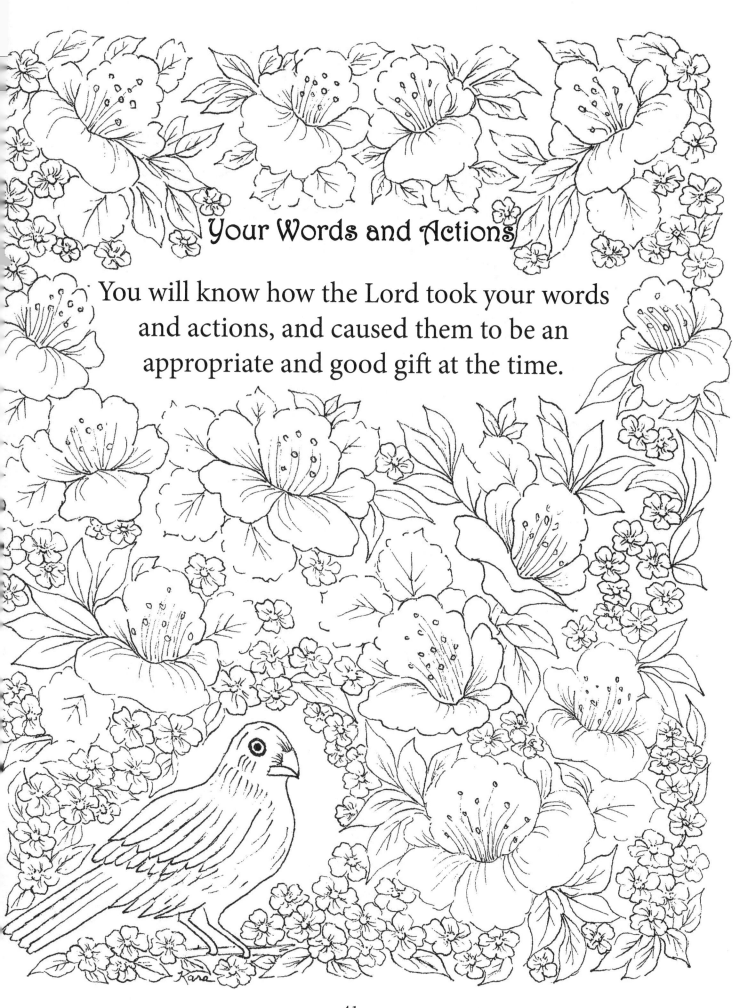

Your Words and Actions

You will know how the Lord took your words and actions, and caused them to be an appropriate and good gift at the time.

A Solitary Place

Each one who desires to go deeper with the Lord must come to a solitary place where they can listen and hear and walk with the Lord.

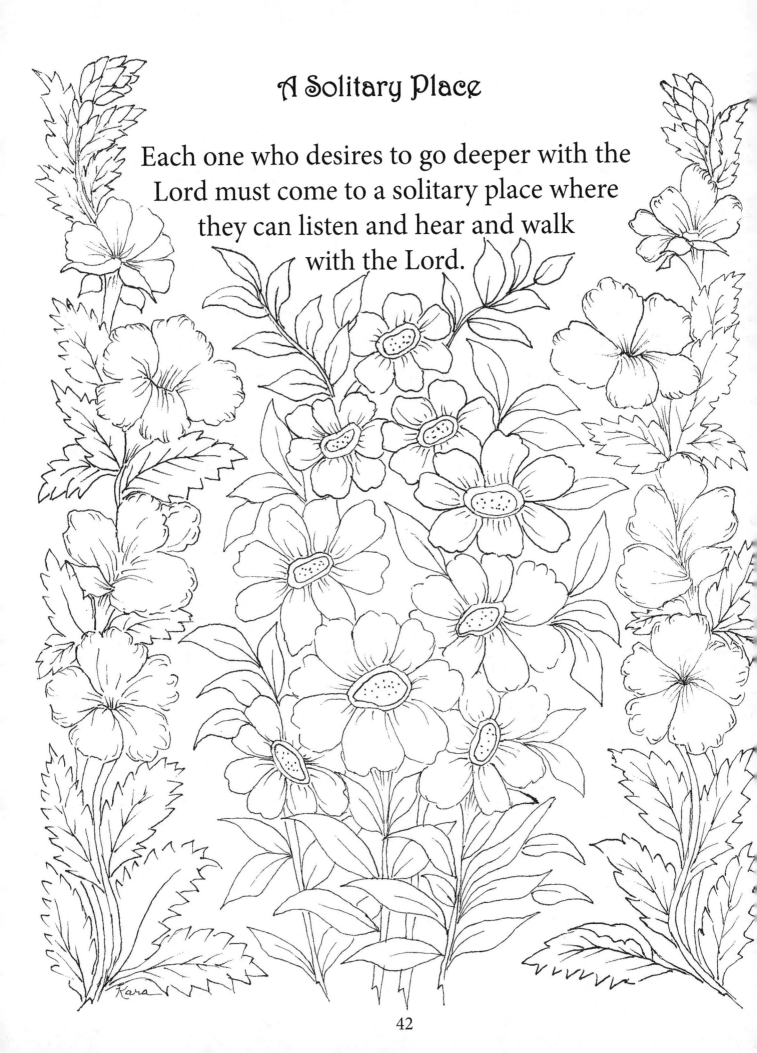

Wait Before the Lord

There shall be a peace within your heart, that as you wait before the Lord, and as you listen to Him, you shall receive fully from Him.

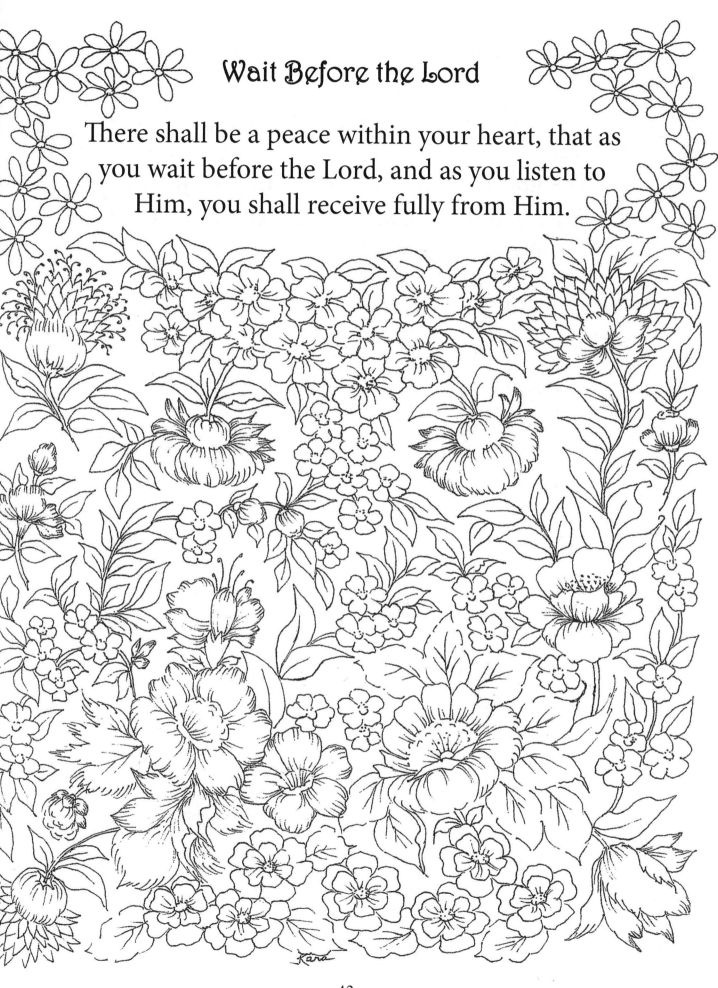

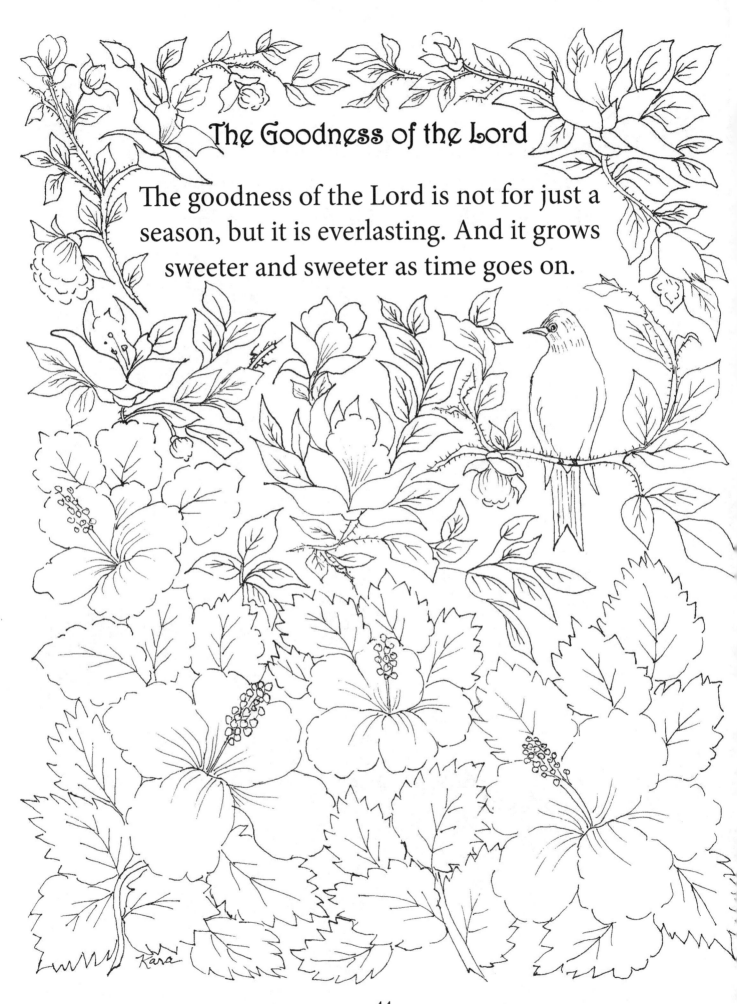

The Goodness of the Lord

The goodness of the Lord is not for just a season, but it is everlasting. And it grows sweeter and sweeter as time goes on.

A Song of Rejoicing

The Lord would say that your joy shall overflow.
And that joy which is within you shall be like a
song within your heart; a song of rejoicing, and a
song of praises, and a song where you will know
that the goodness of the Lord is within you.

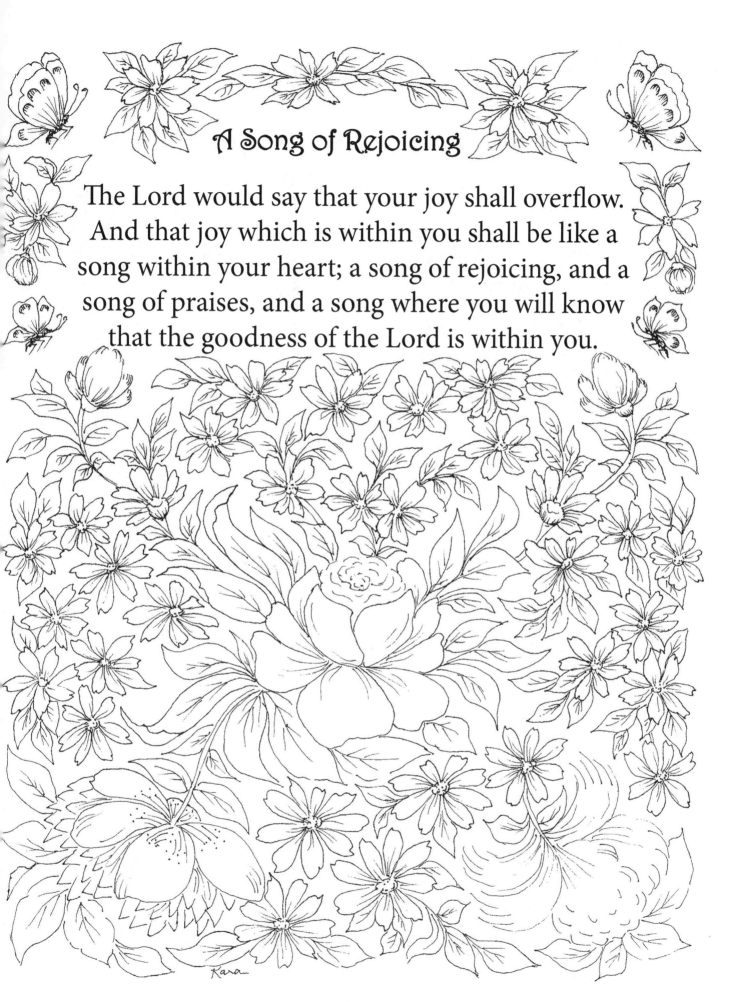

Walk with a Blessing

You will walk with a blessing from the Lord
when you give to others.

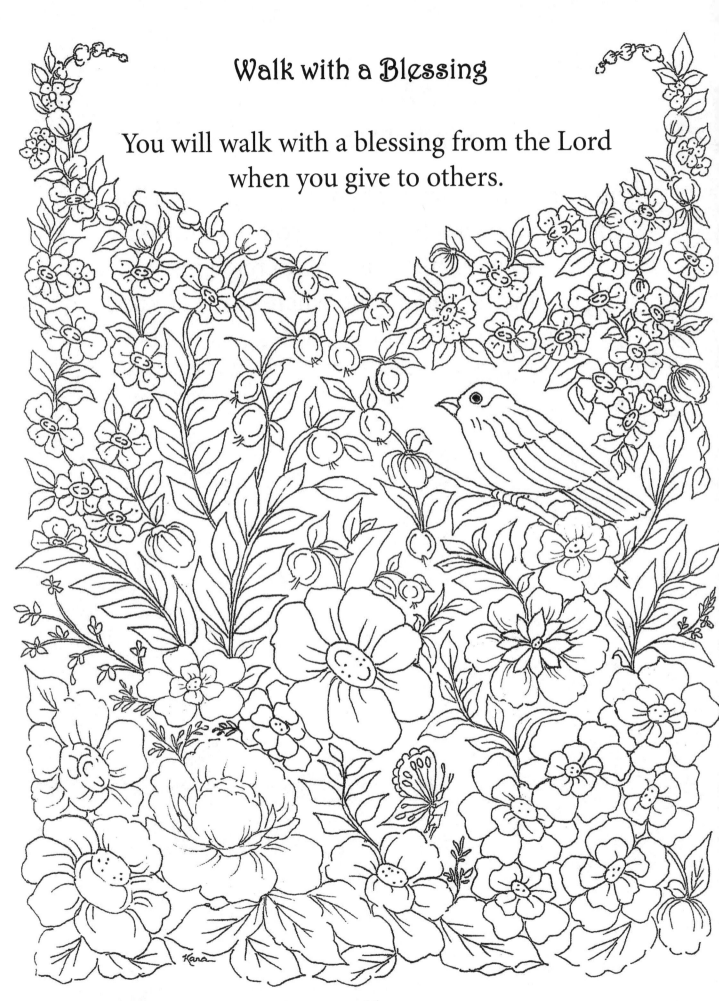

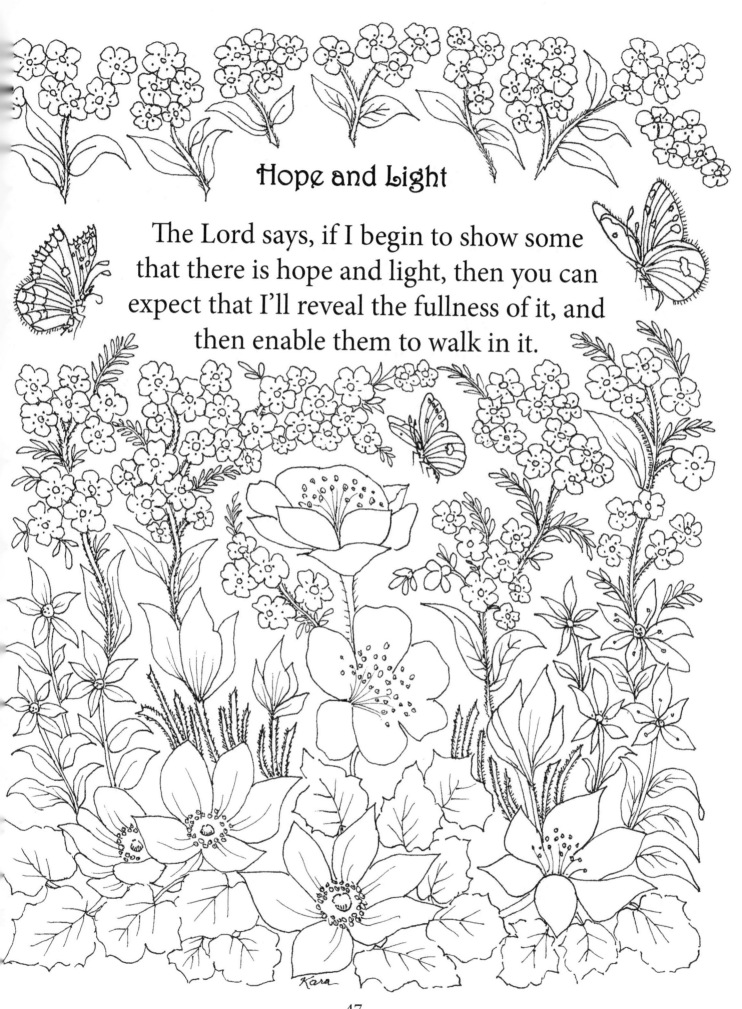

Hope and Light

The Lord says, if I begin to show some that there is hope and light, then you can expect that I'll reveal the fullness of it, and then enable them to walk in it.

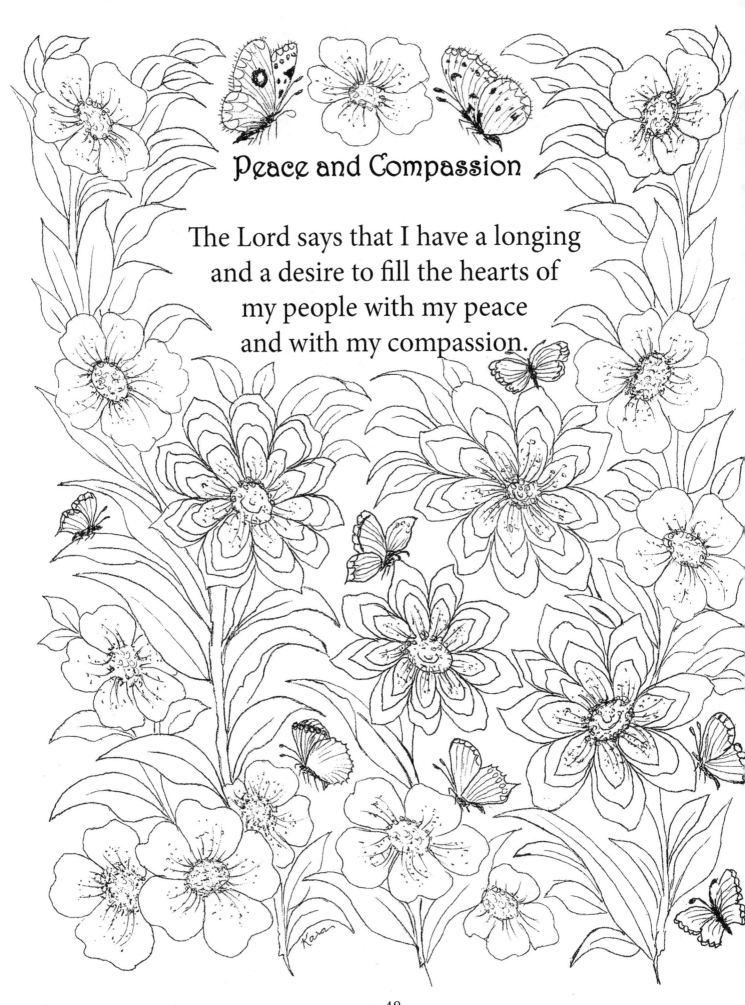

Peace and Compassion

The Lord says that I have a longing
and a desire to fill the hearts of
my people with my peace
and with my compassion.

Peace within your Heart

You can be at peace within your heart that the Lord is doing a gracious work.

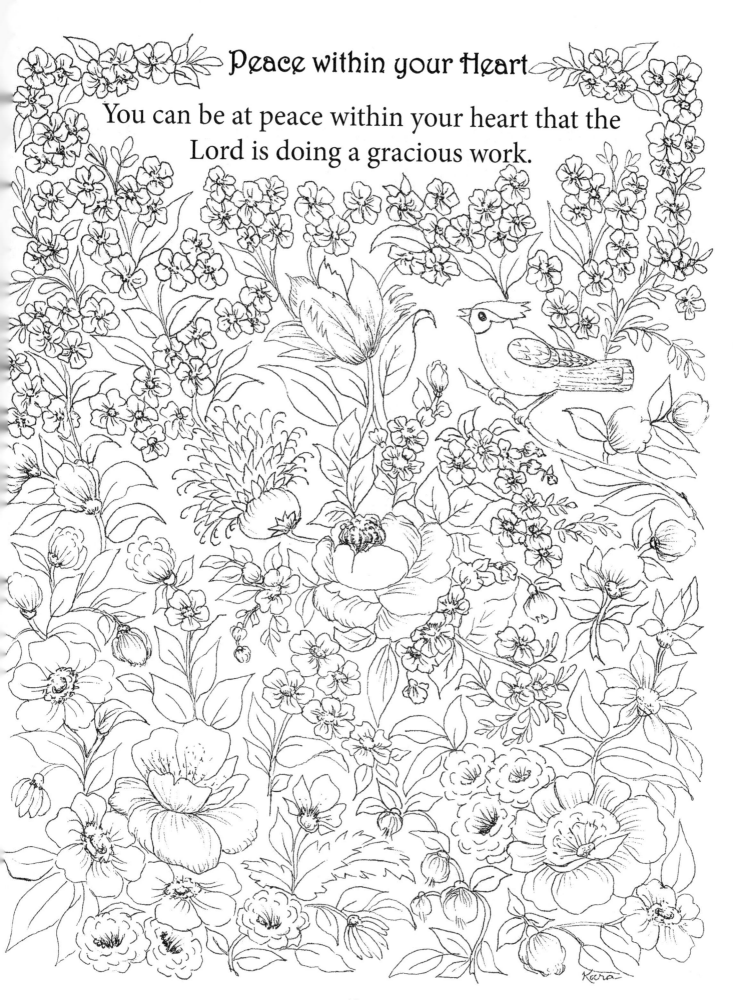

Walk with the Lord

As you walk with the Lord, you will find that the Lord's faithfulness will go with you.

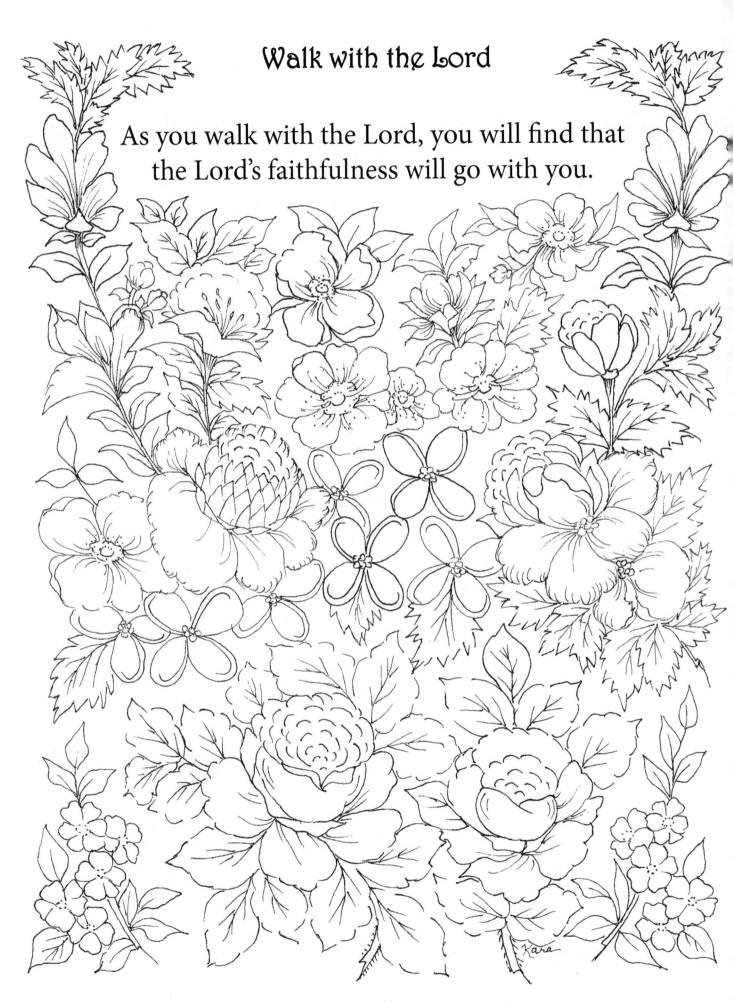

The Love of the Lord

As your heart pours forth the love and
encouragement of the Lord, it shall be a time
of great refreshing and strengthening and
encouragement for you and others.

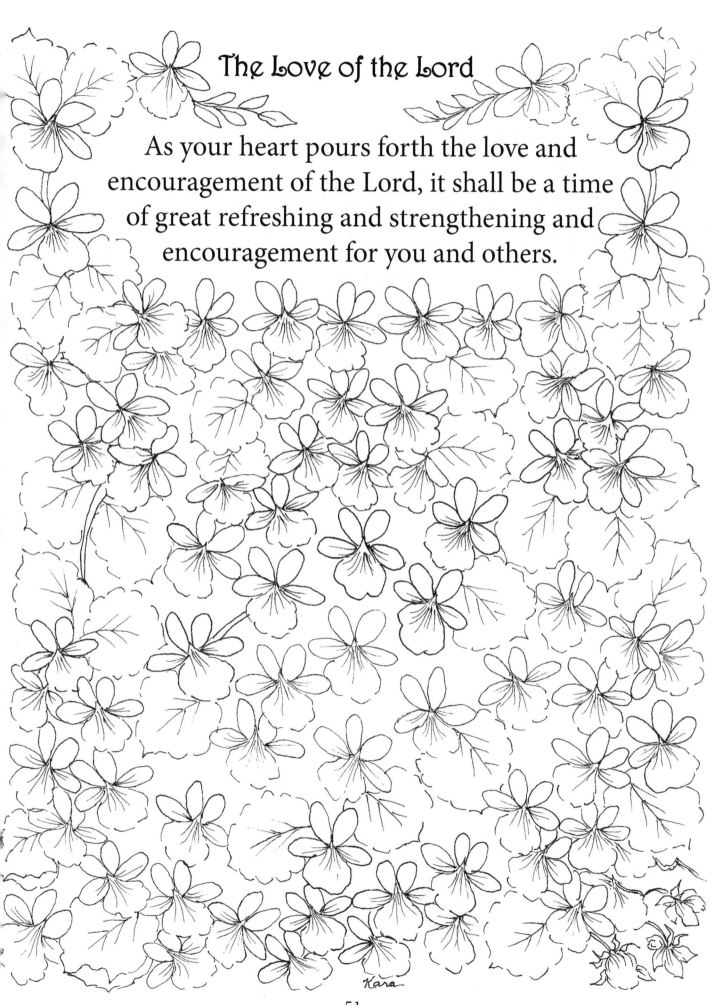

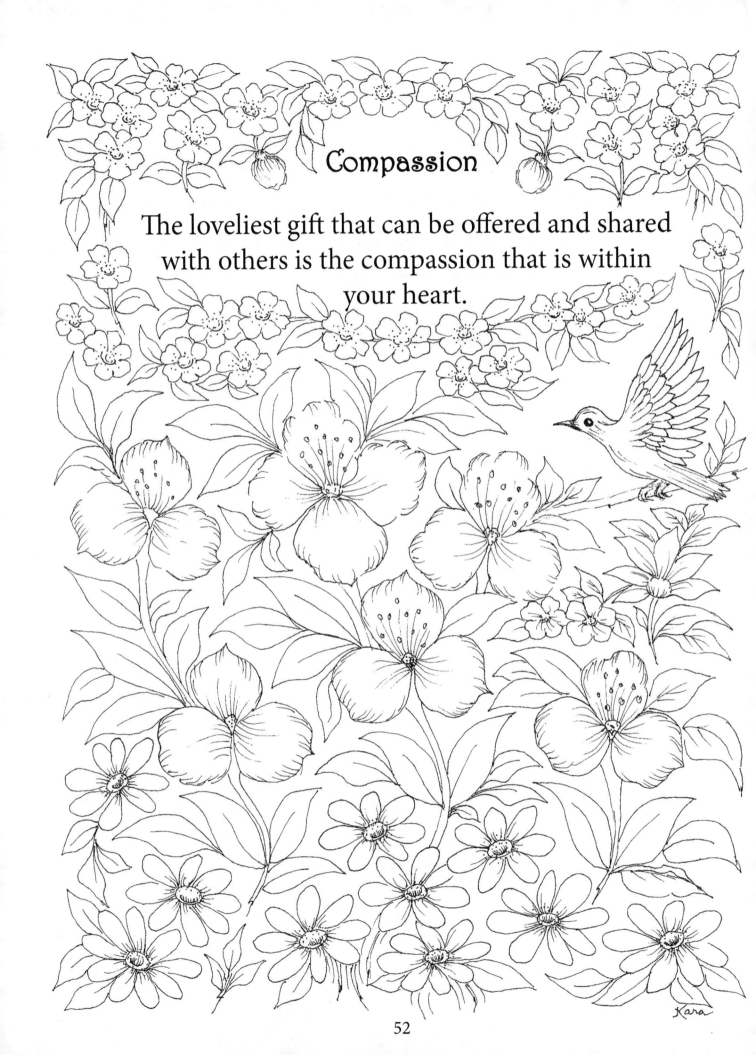

Compassion

The loveliest gift that can be offered and shared with others is the compassion that is within your heart.

Hear His Voice

The Lord is longing for hearts that would hear his voice, and hearts that would listen, and then proclaim to others what they hear.

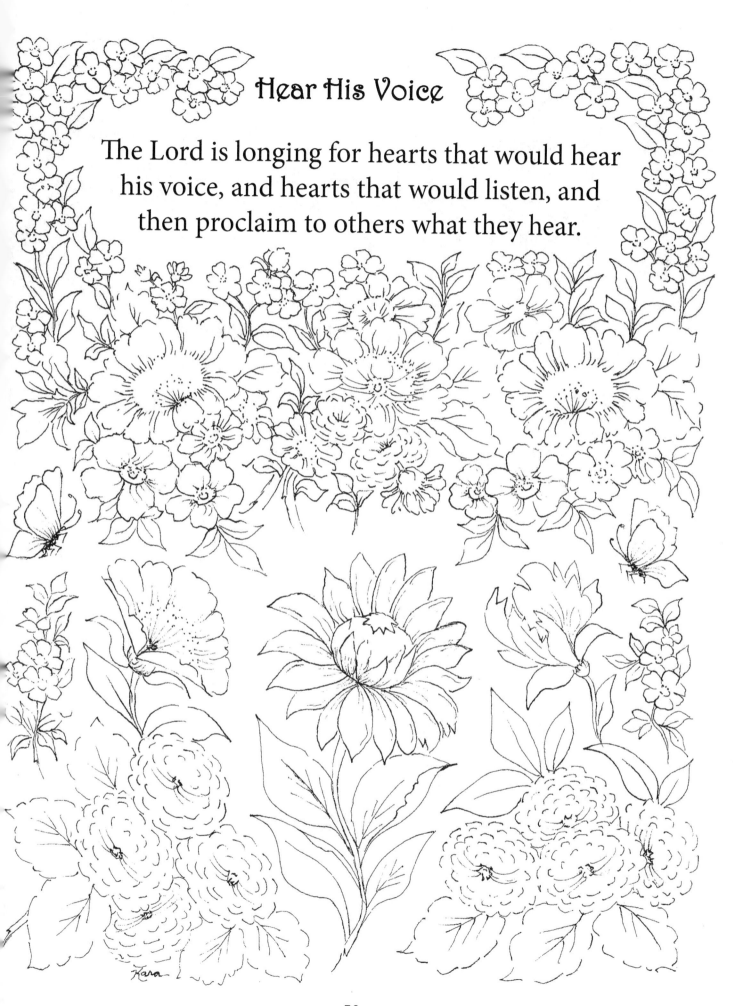

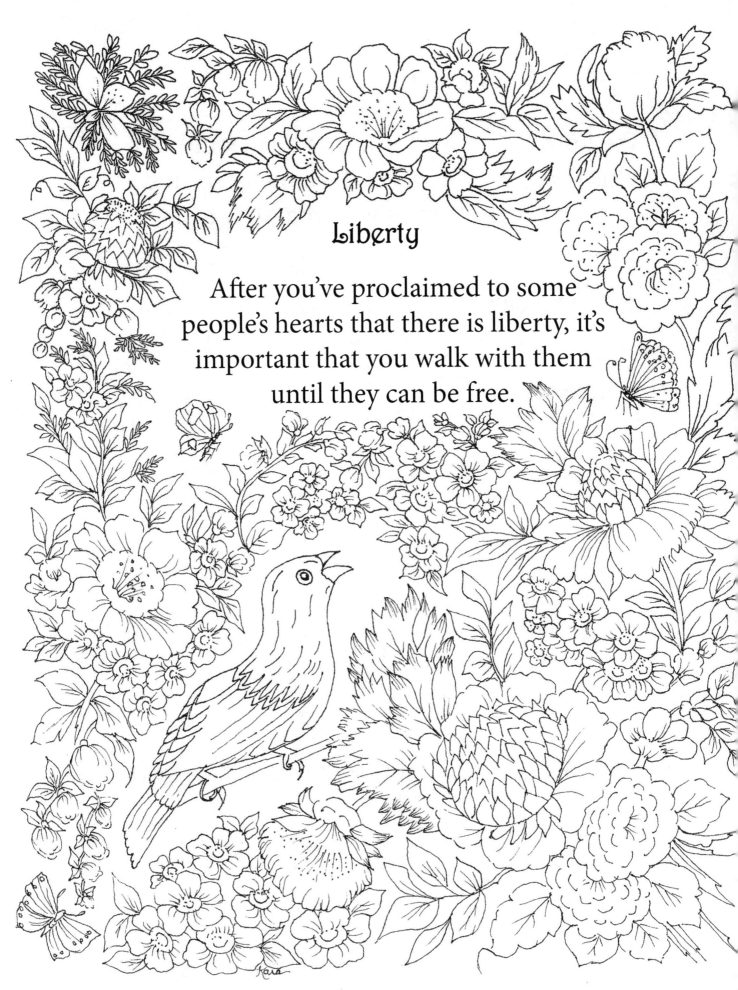

Liberty

After you've proclaimed to some people's hearts that there is liberty, it's important that you walk with them until they can be free.

The Lord is Close

The Lord is one who is close at hand, and he is one who will lead you and direct you.

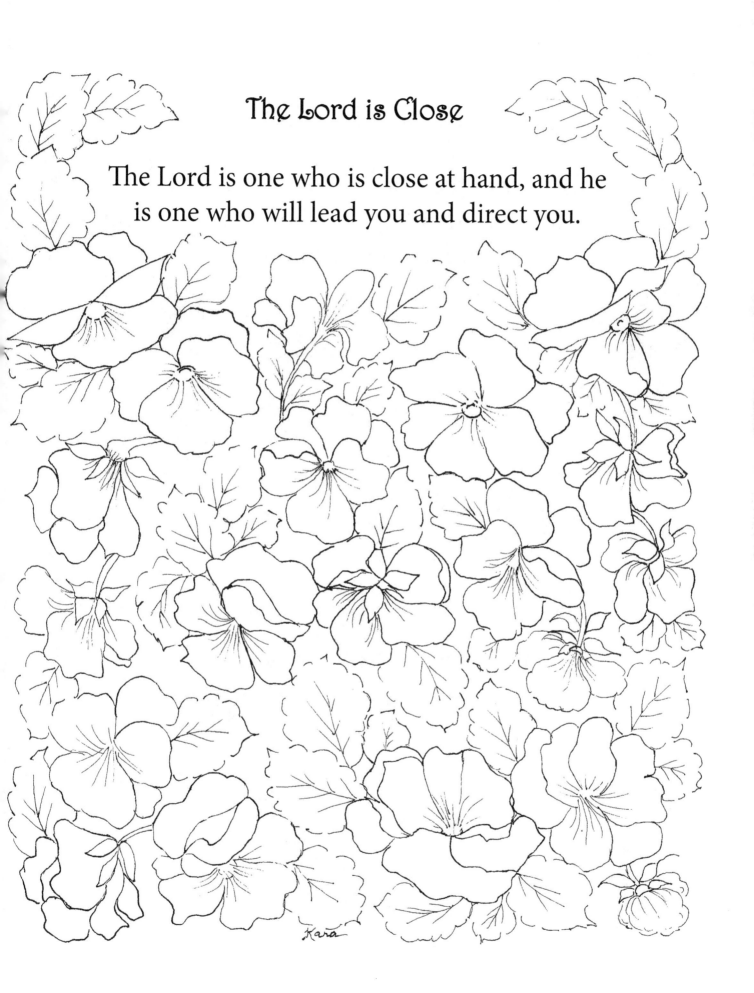

The Joy of the Lord

The joy of the Lord is not found in your circumstances, but in your heart, because the Lord loves you so much.

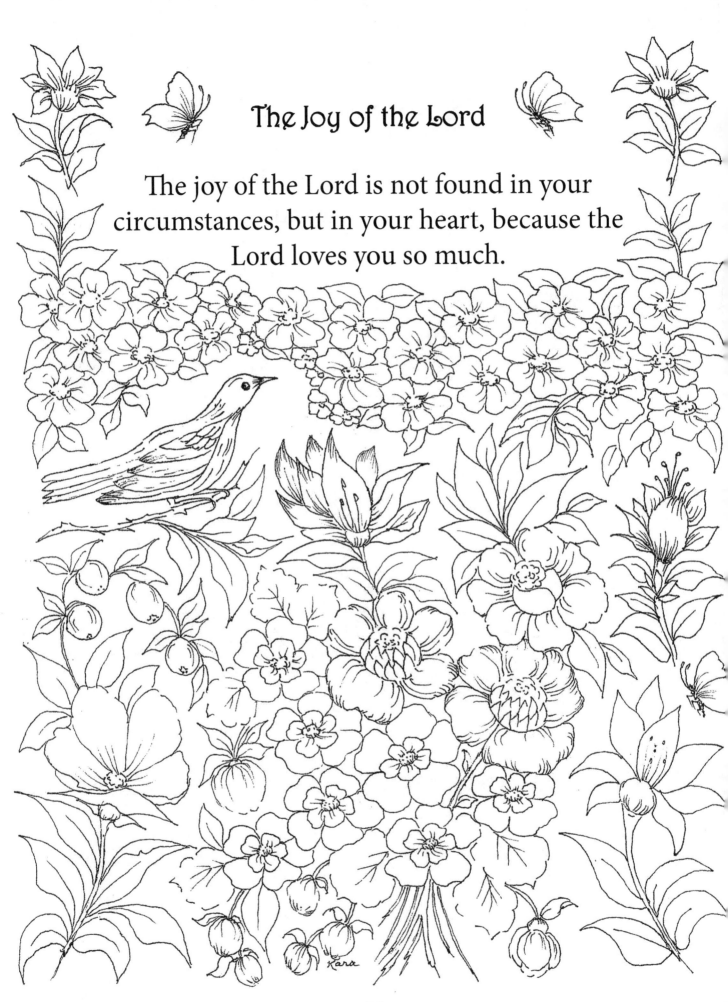

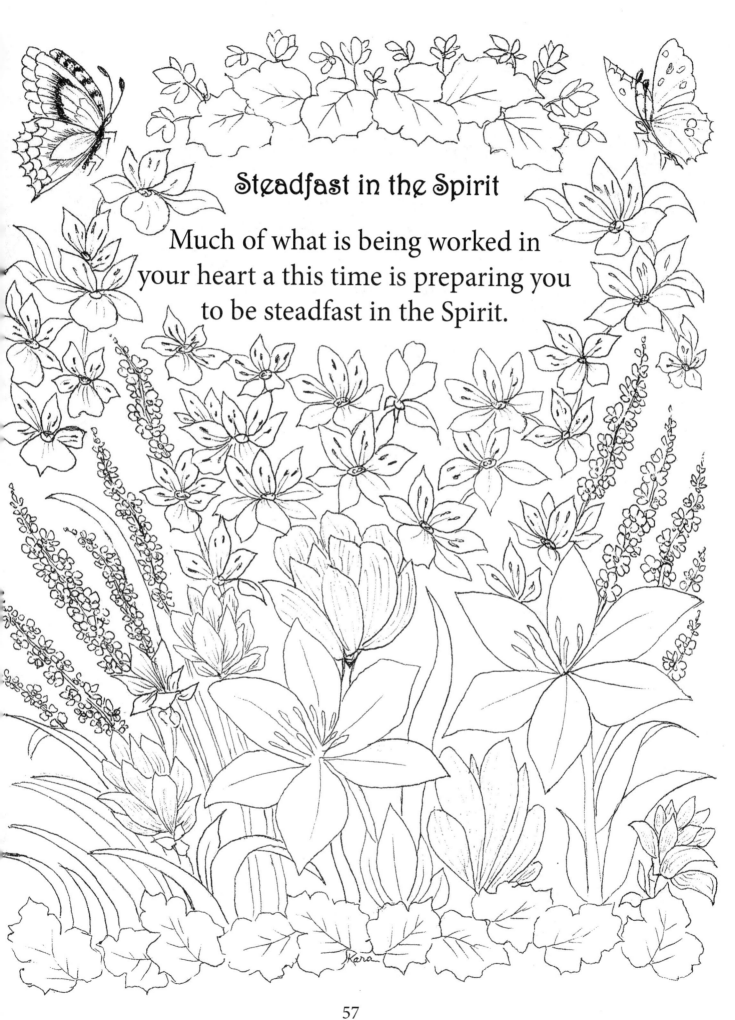

Steadfast in the Spirit

Much of what is being worked in
your heart a this time is preparing you
to be steadfast in the Spirit.

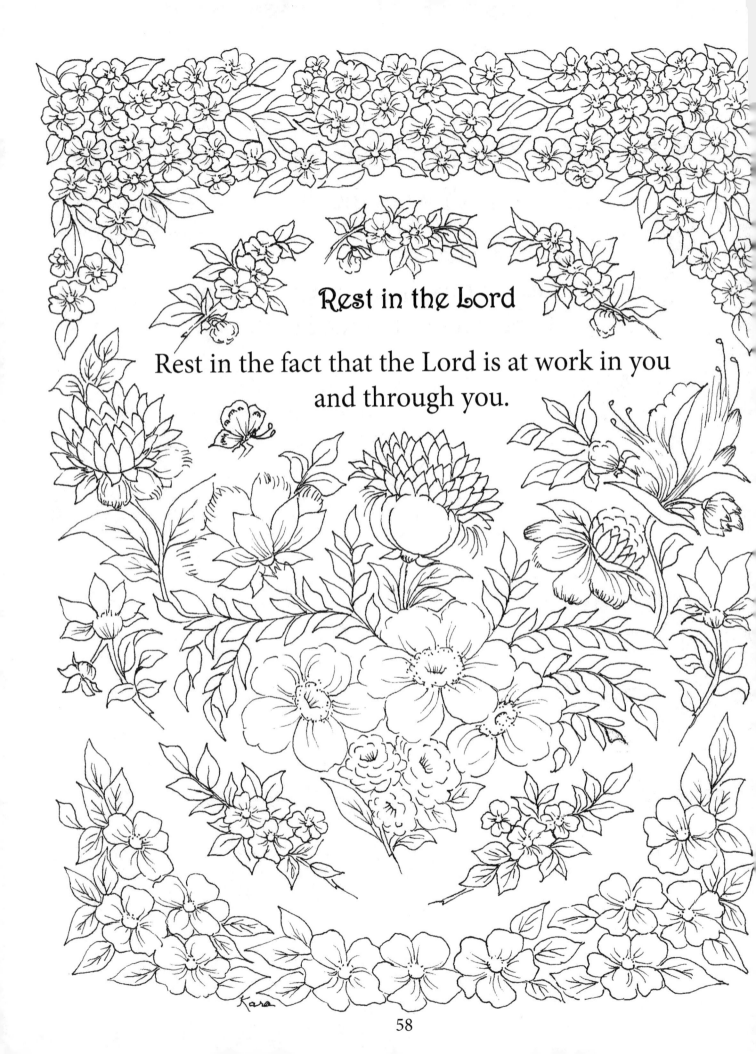

Rest in the Lord

Rest in the fact that the Lord is at work in you and through you.

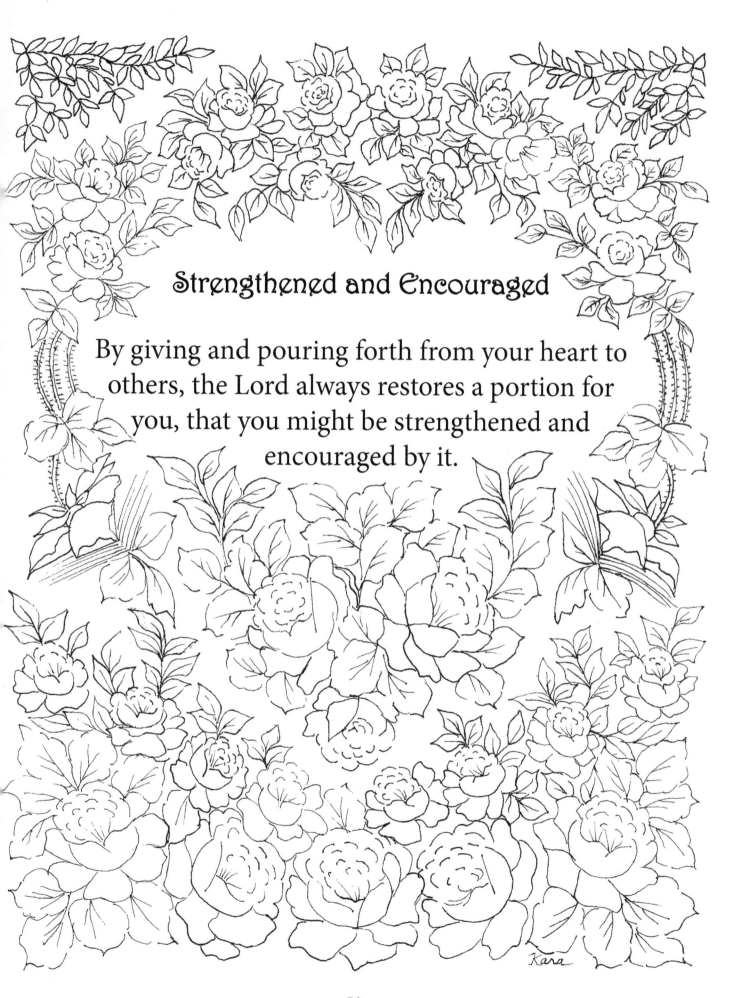

Strengthened and Encouraged

By giving and pouring forth from your heart to others, the Lord always restores a portion for you, that you might be strengthened and encouraged by it.

CPSIA information can be obtained
at www.ICGtesting.com
Printed in the USA
LVHW060330221019
634942LV00021B/1923/P